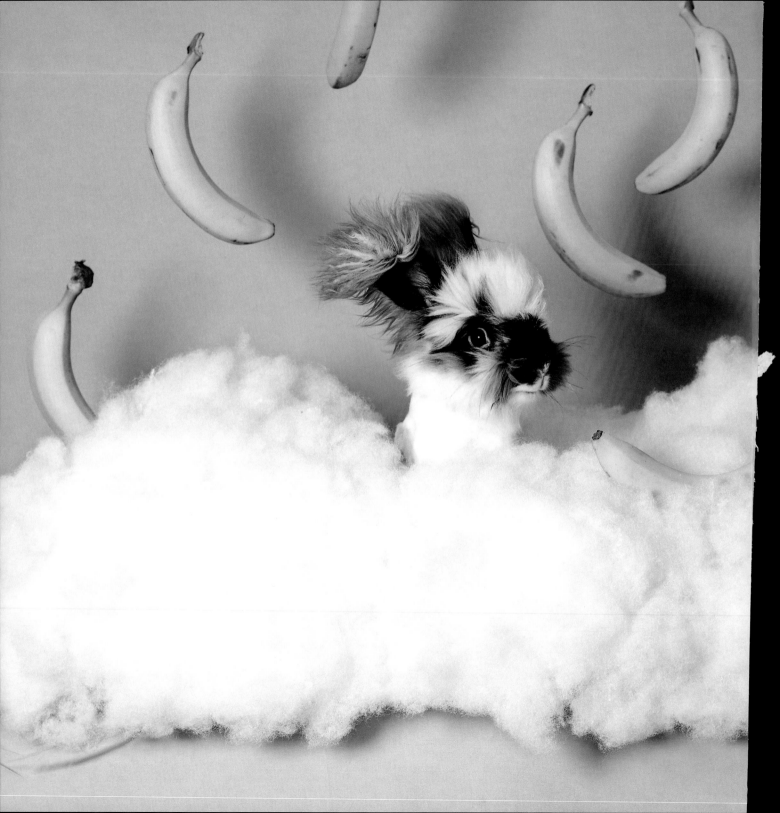

a Bunny named BARNABY

IT'S A BUN LIFE

KATJA RUSSELL & NICK McGINN, JR.

Turner Publishing Company

Nashville, Tennessee

www.turnerpublishing.com

Cover design: Maddie Cothren

Book design: Stacy Wakefield Forte

Library of Congress Cataloging-in-Publication Data Upon Request

9781684422159 Hardcover

9781684422166 eBook

Printed in the United States of America

17 18 19 20 10 9 8 7 6 5 4 3 2 1

For all Rabbits.

The abandoned,
the rescued,
the grumpy,
the cute.

And to those
who clean their
poop.

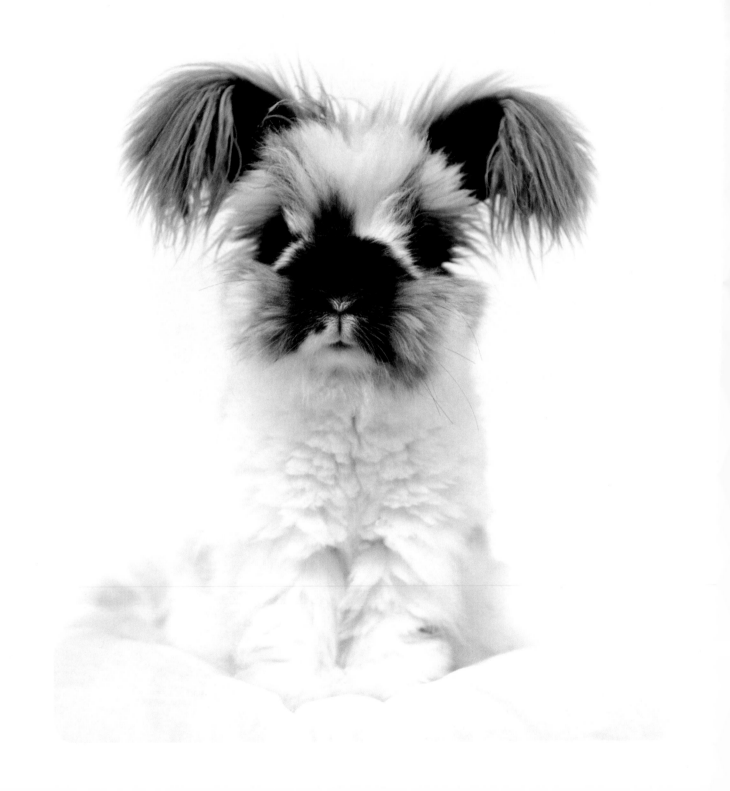

THE
basic
bun

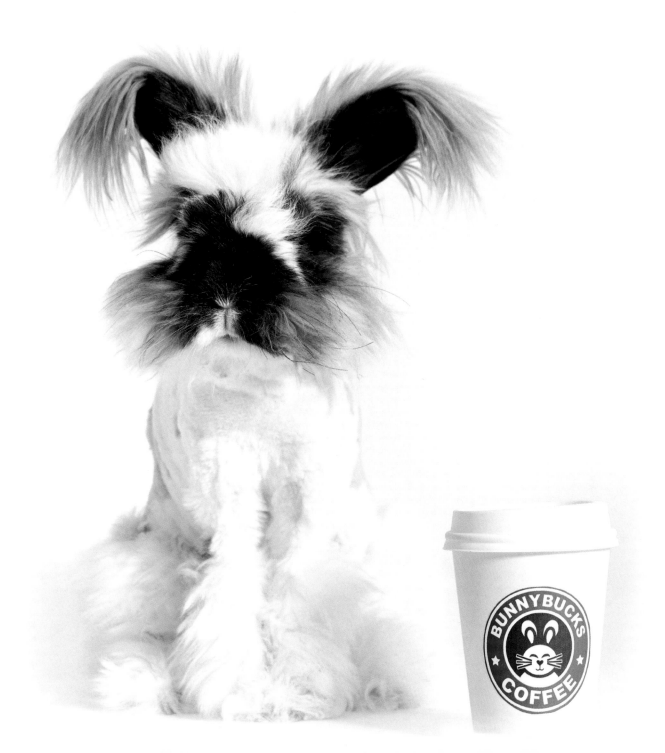

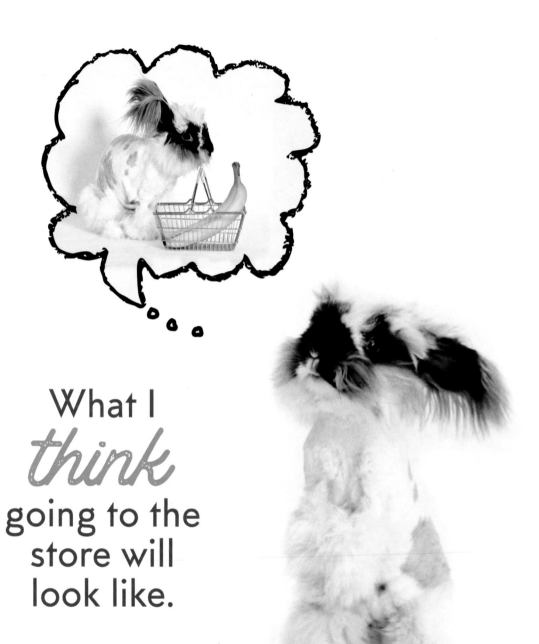

What I *think* going to the store will look like.

VS

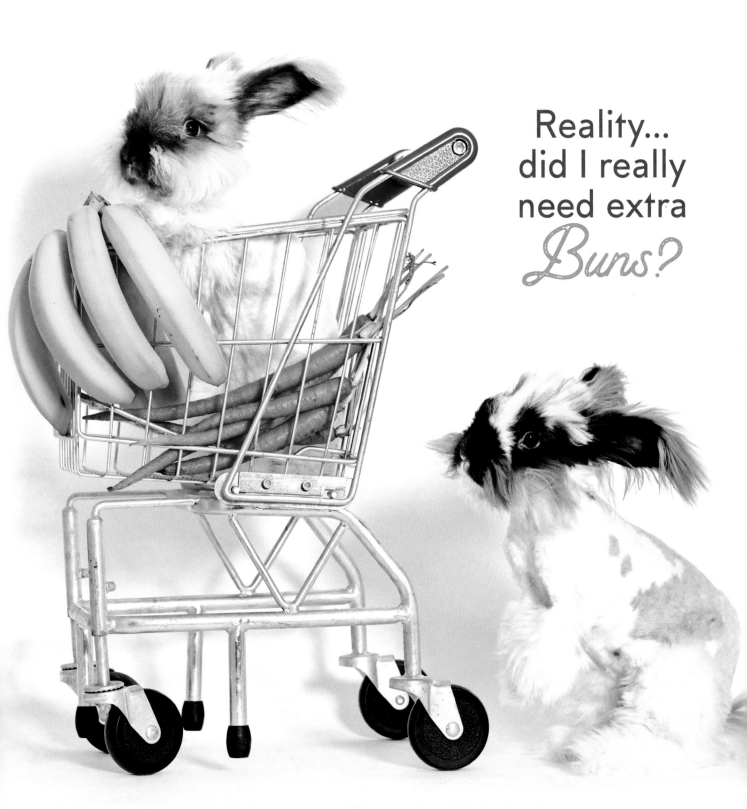

Reality...
did I really
need extra
Buns?

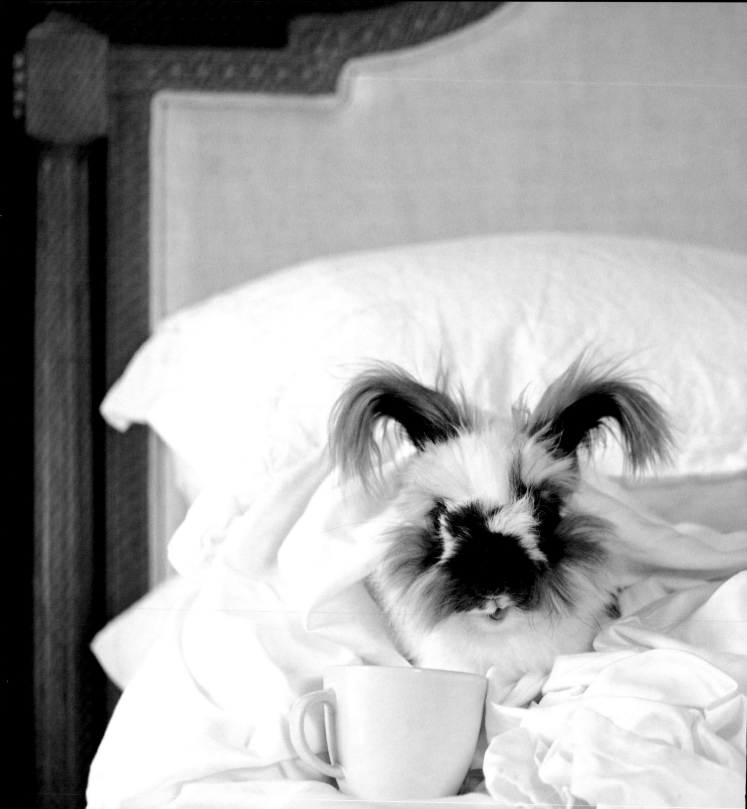

It's a Brewtiful Day

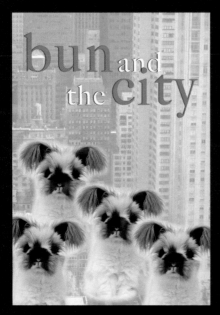

Bun and the City

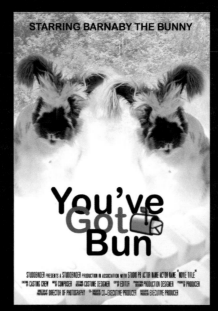

You've Got Bun

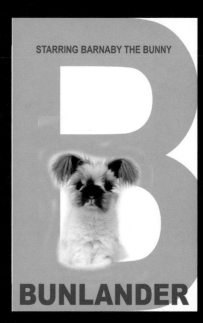

Bunlander

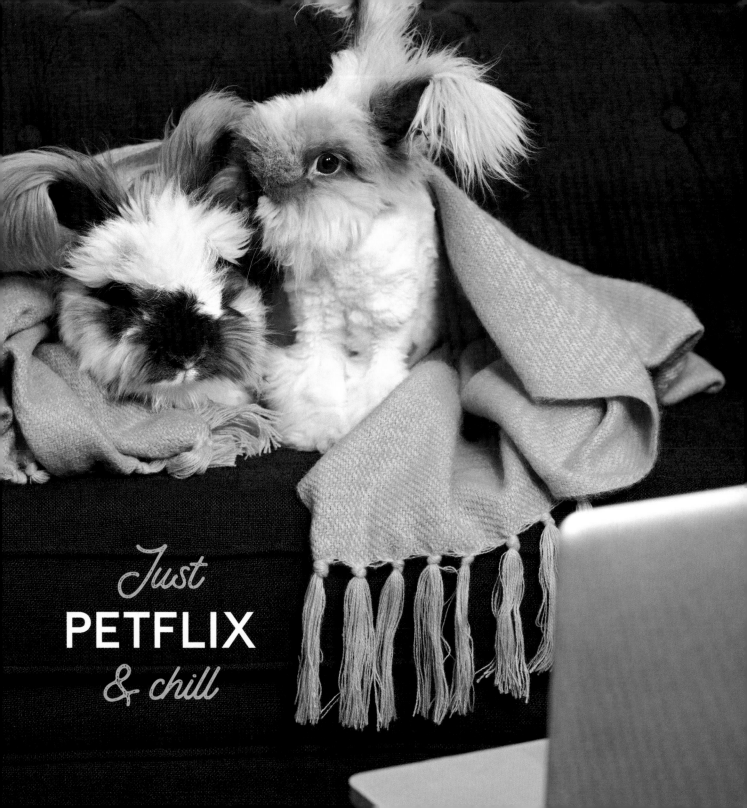

I'm bringing
basic back

* *Hop* *

those other
bunnies
don't know
how to act.

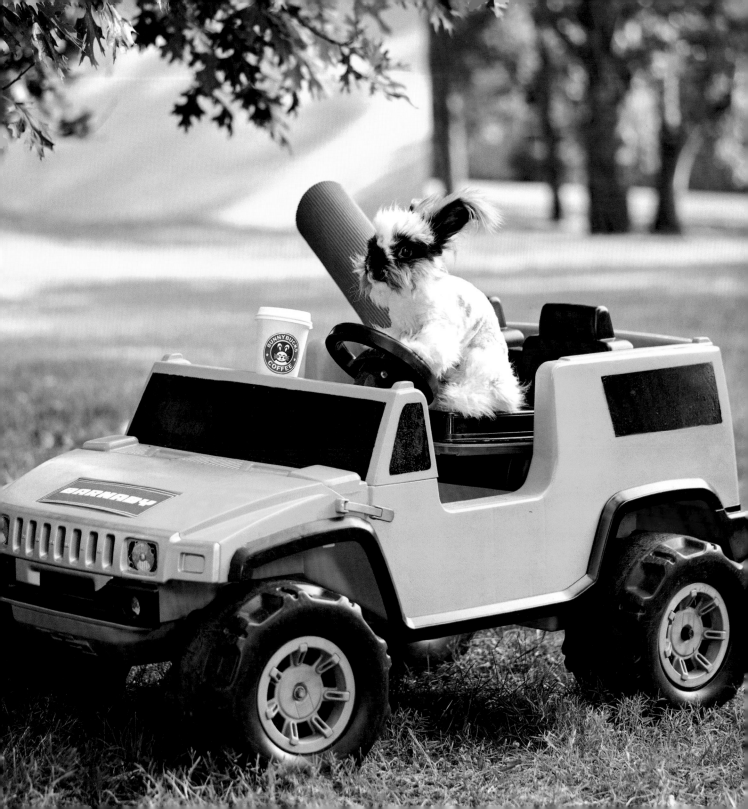

#itsabunlife

#basic

#bananas

#imsofluffy

#adoptdontshop

#funnbunny

#notadog

#hashtag

#bunnybucks

#abunnynamedbarnaby

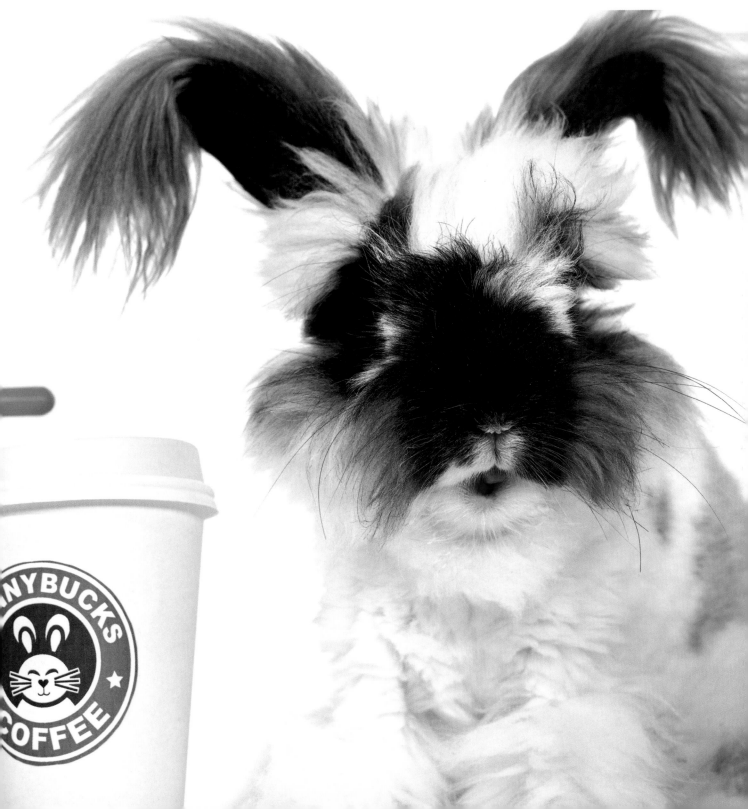

THE
man
bun

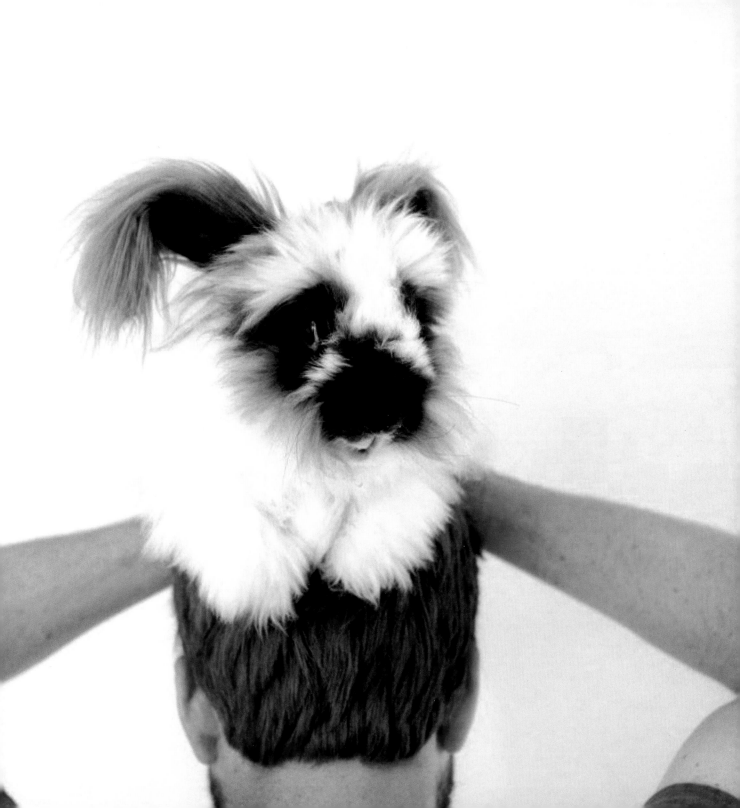

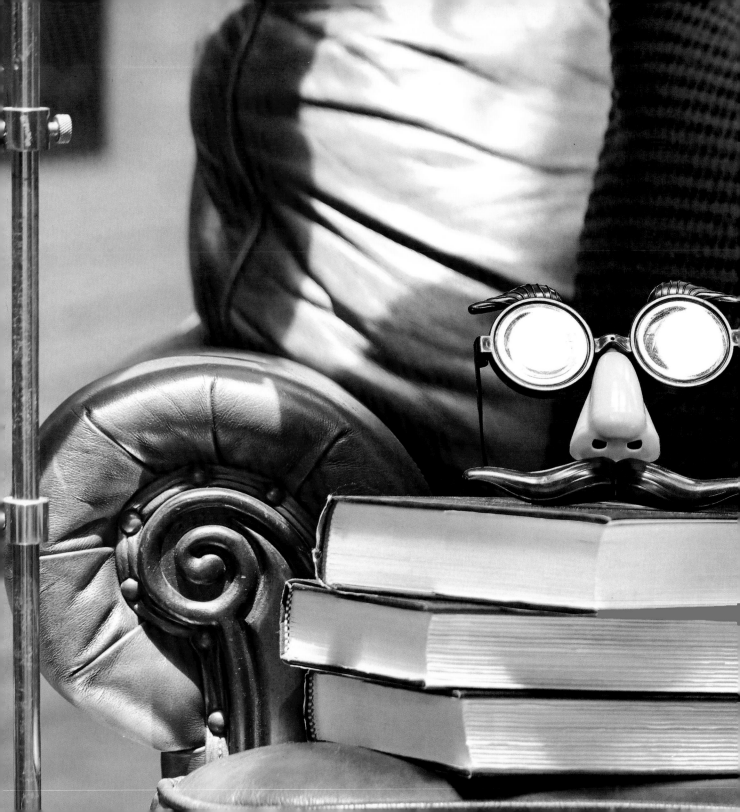

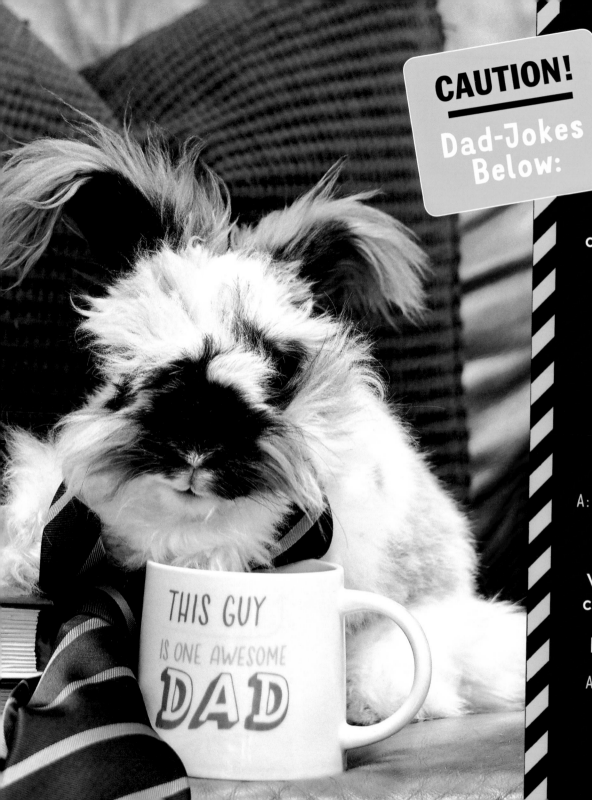

Q:

How do you catch a unique bunny?

A: UNIQUE UP ON IT.

Q:

What do bunnies say before they eat?

A: LETTUCE PRAY.

Q:

What do you call 5 bunnies hopping backwards?

A: A RECEDING HAIR LINE.

THIS GUY IS ONE AWESOME DAD

The essentials for a good home brew

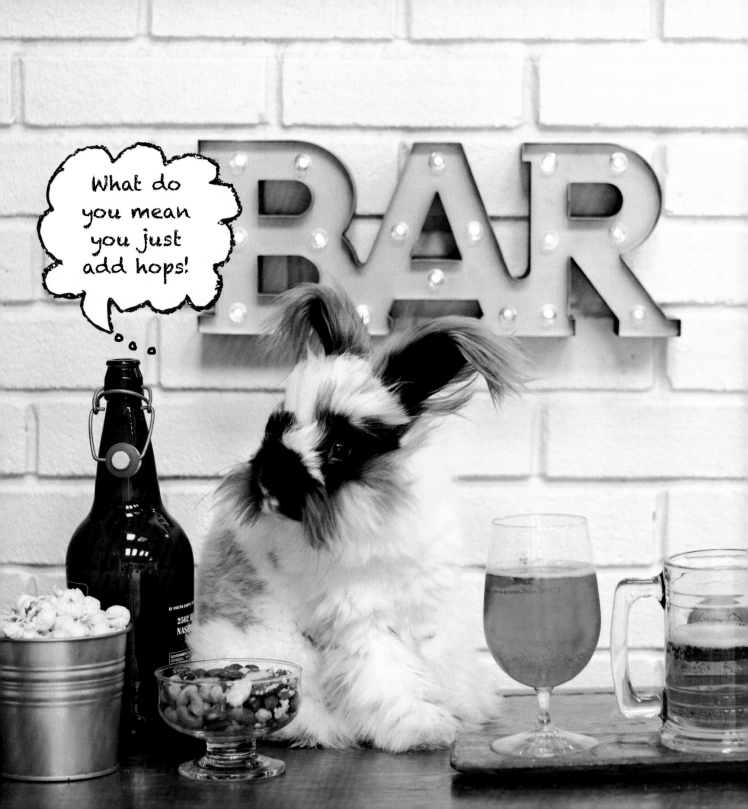

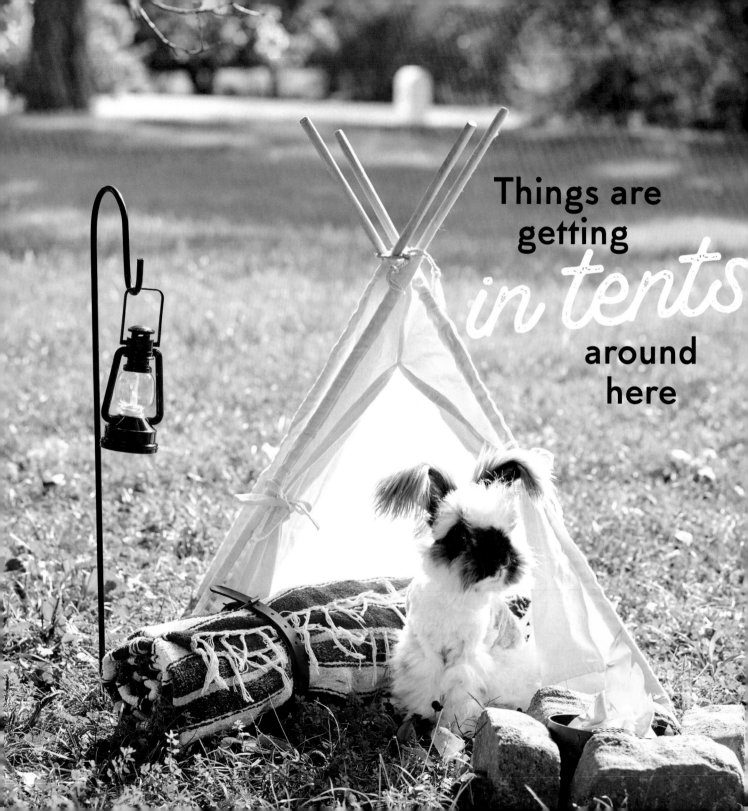

Things are getting *in tents* around here

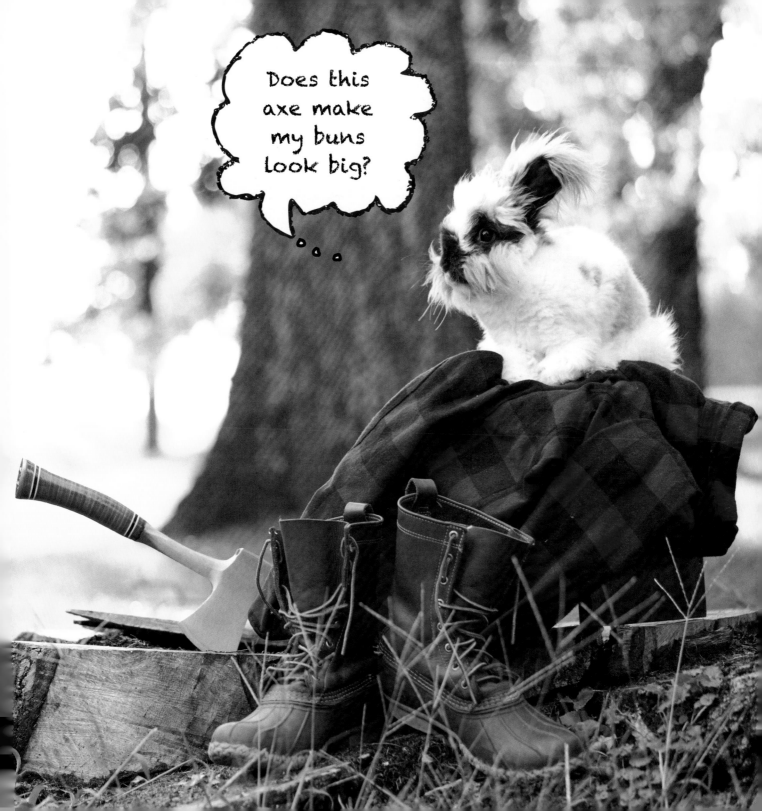

bunny bread

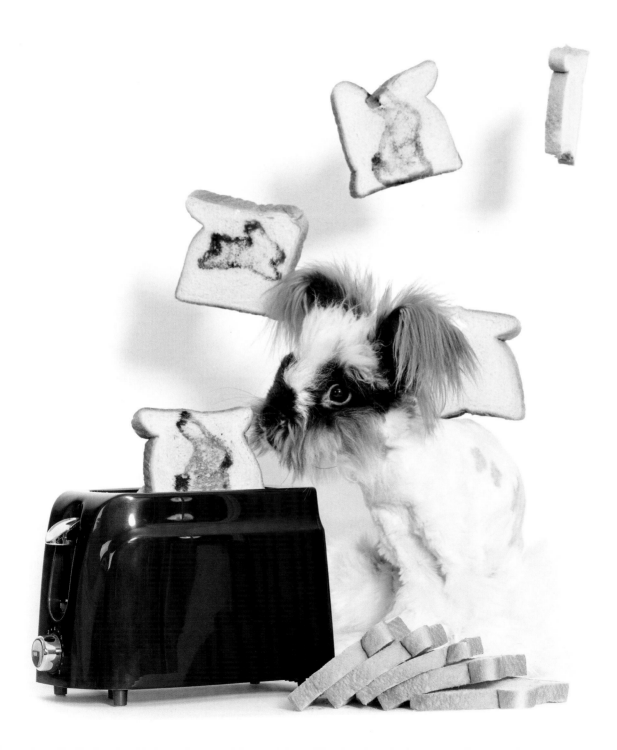

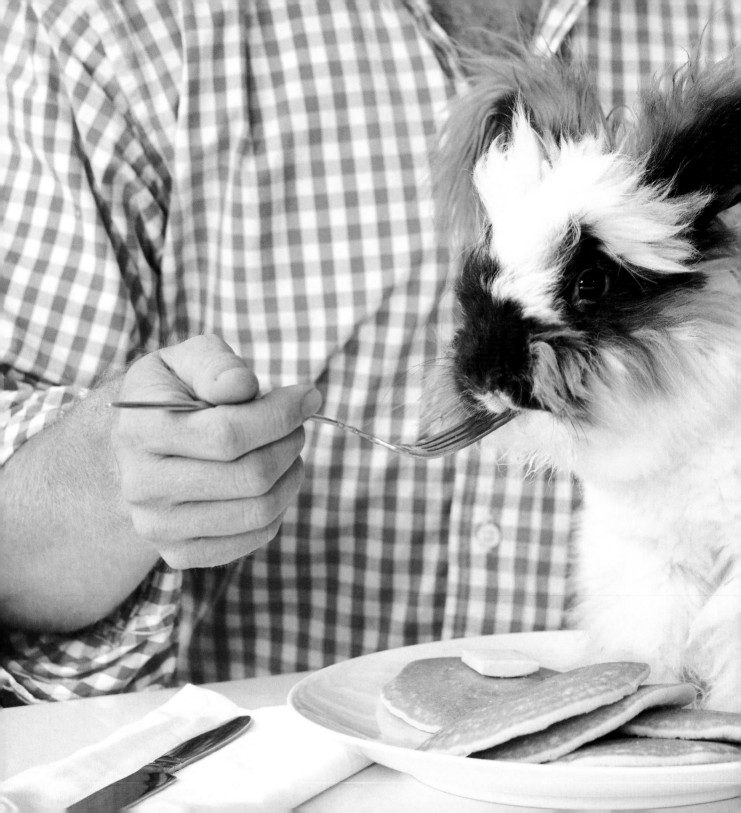

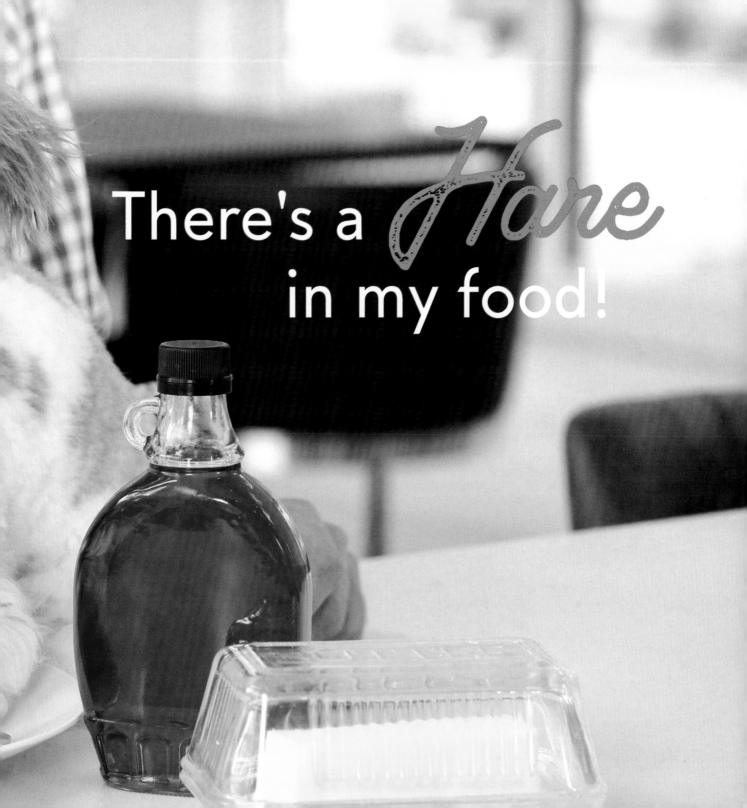

There's a *Hare* in my food!

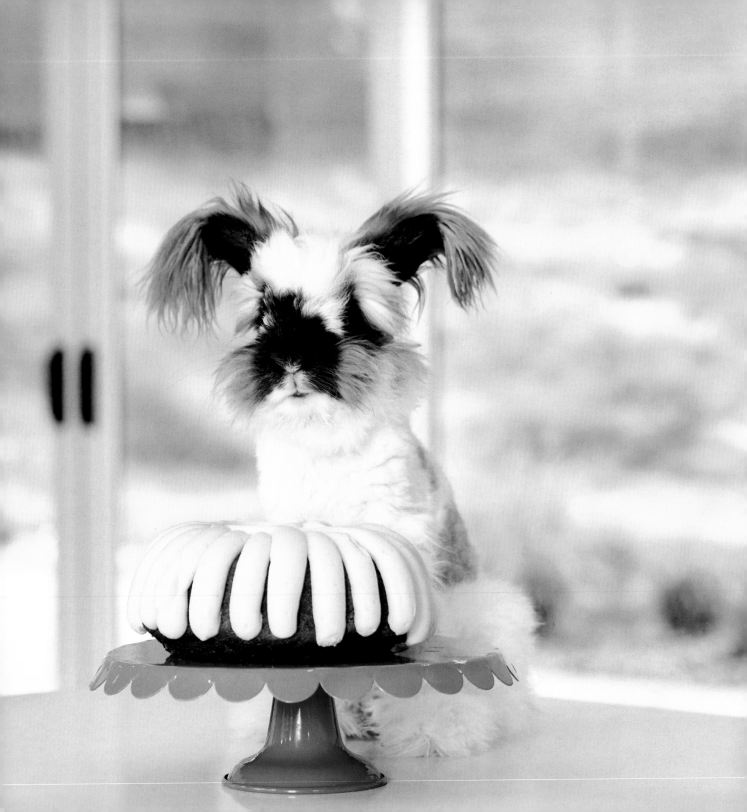

a Recipe for the Perfect
CARROT-BANANA BUN'T CAKE

INGREDIENTS

CAKE

2 cups all purpose flour
1 tablespoon ground cinnamon
2 teaspoons baking soda
¼ teaspoon salt
1 cup vegetable oil
1 cup sugar
1 cup firmly packed golden brown sugar
4 large eggs
1½ cups finely grated carrots
(about 1½ large)
1 cup drained canned crushed
pineapple in juice
½ cup mashed ripe banana
¾ cup chopped pecans

FROSTING

1 8-ounce package cream cheese,
room temperature
1 cup powdered sugar
3 tablespoons unsalted butter,
room temperature
¼ teaspoon ground cinnamon
Additional ground cinnamon

PREPARATION

FOR CAKE: Preheat oven to
350°F. Grease and flour 12-cup
Bundt pan. Sift first 4 ingredients
into medium bowl. Whisk oil, 1 cup
sugar, brown sugar and eggs in
large bowl until well blended. Mix
in dry ingredients. Add carrots,
pineapple, banana and pecans
and blend well. Transfer batter to
prepared pan. Bake until tester
inserted near center of cake comes
out clean (about 1 hour). Let cake
stand in pan 10 minutes. Turn out
cake onto rack and cool.

FOR FROSTING: Beat cream
cheese, powdered sugar, butter and
¼ teaspoon cinnamon in medium
bowl until smooth. Spread frosting
over cake. Sprinkle with additional
cinnamon.

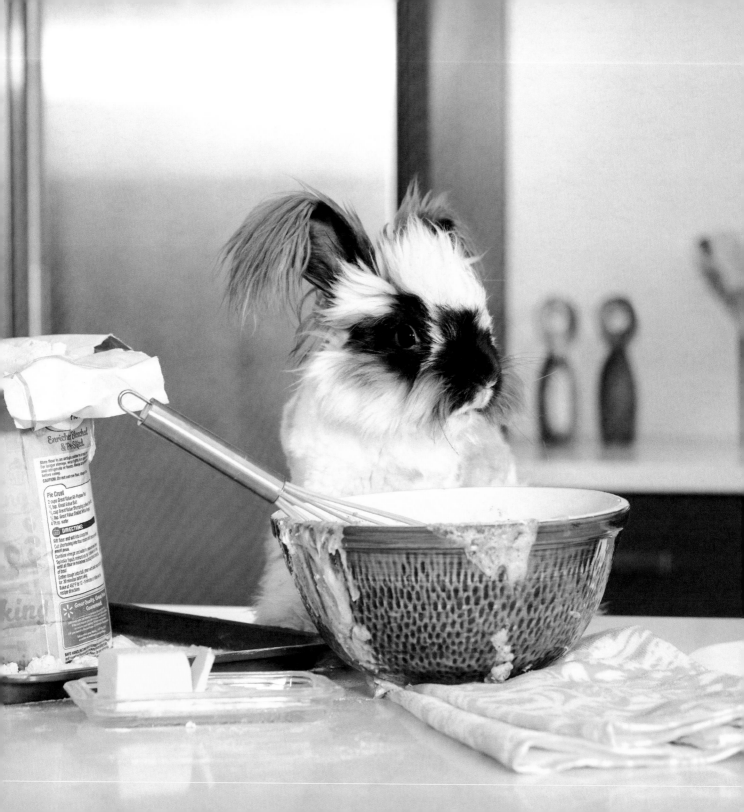

LOOK!

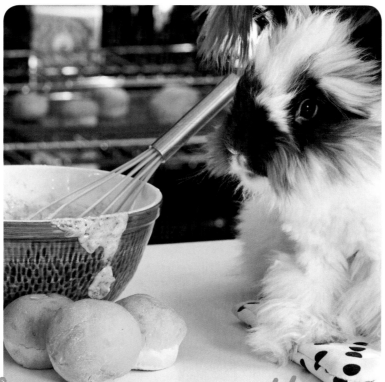

It's a bun in the oven.

Bun Appetit!

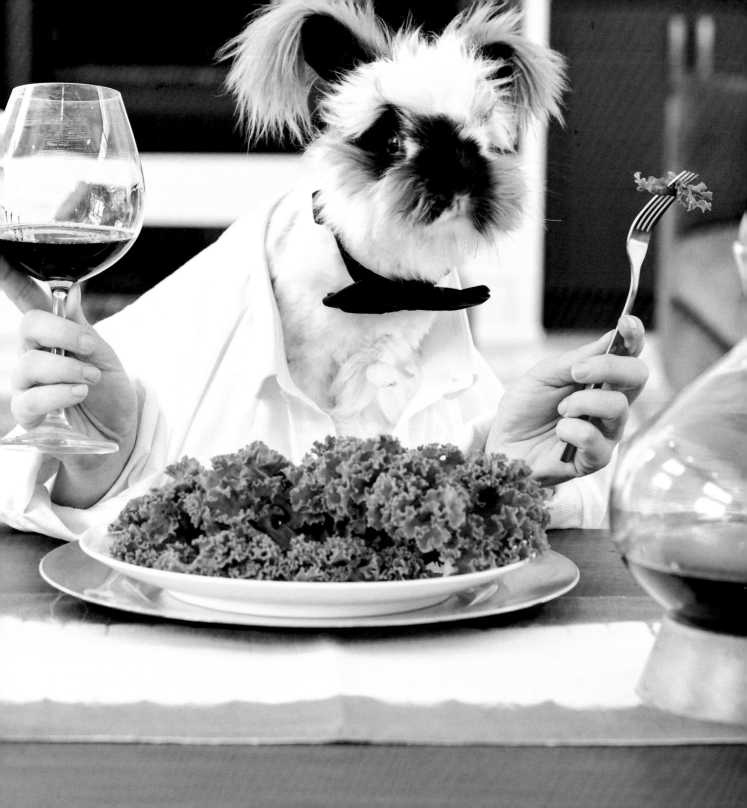

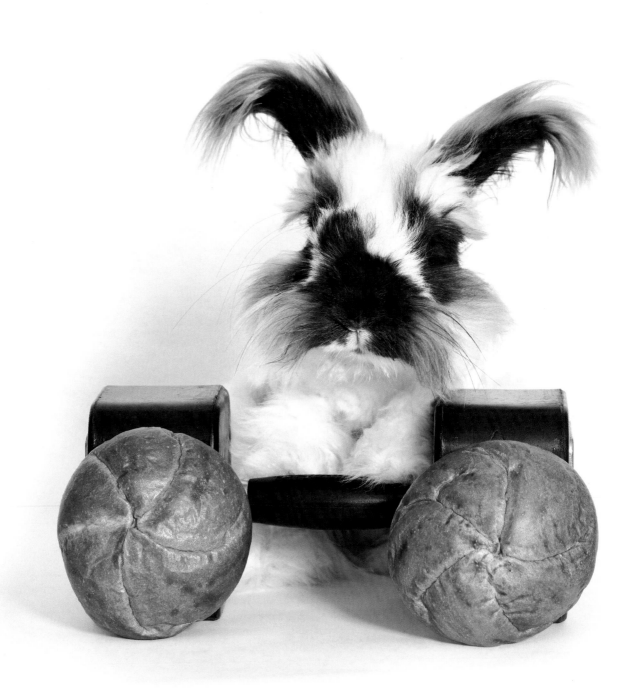

Working my buns off

I've got buns of steel

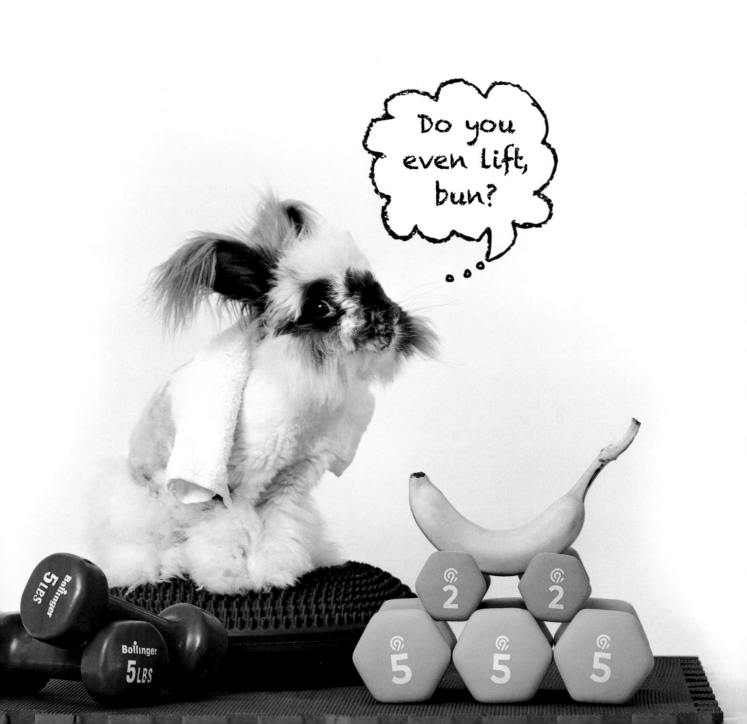

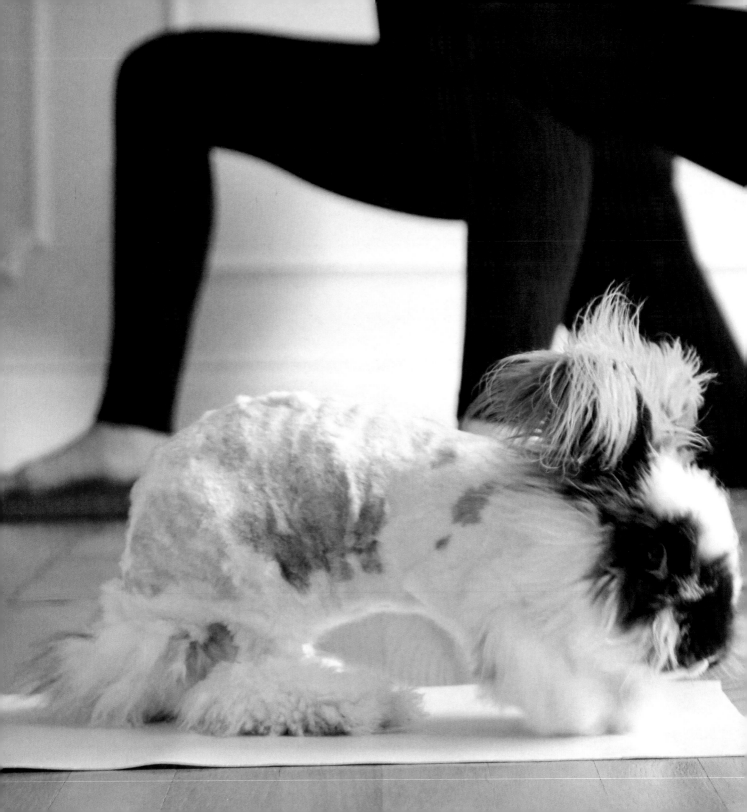

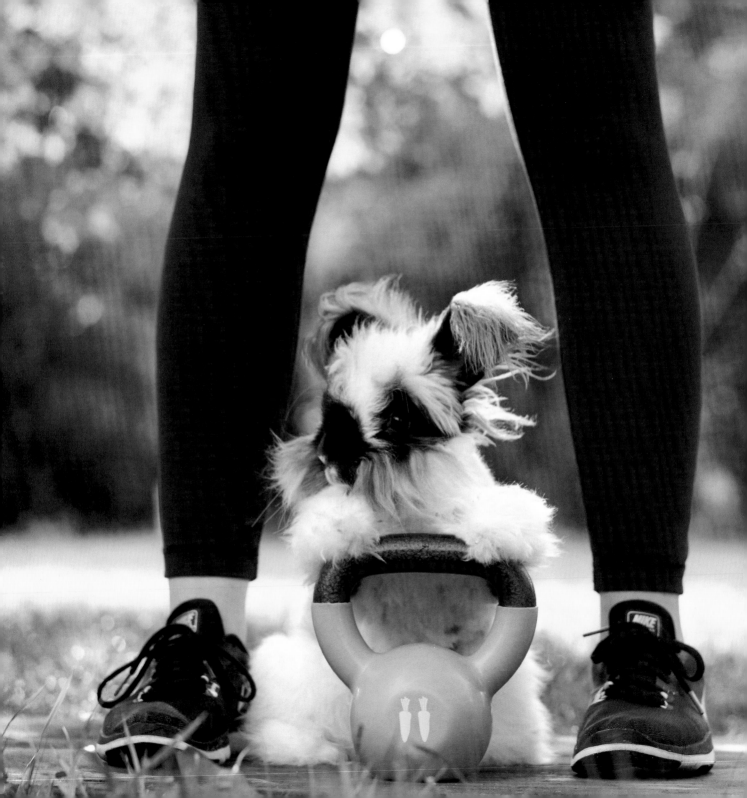

THE *Kettlebun* WORKOUT

COMPLETE AS MANY ROUNDS AS POSSIBLE *in* 10 MINUTES

10
weighted squats to head kisses

10
bun-ups

10
weighted sit-ups to ear rubs

10
lunges (each leg) towards bananas

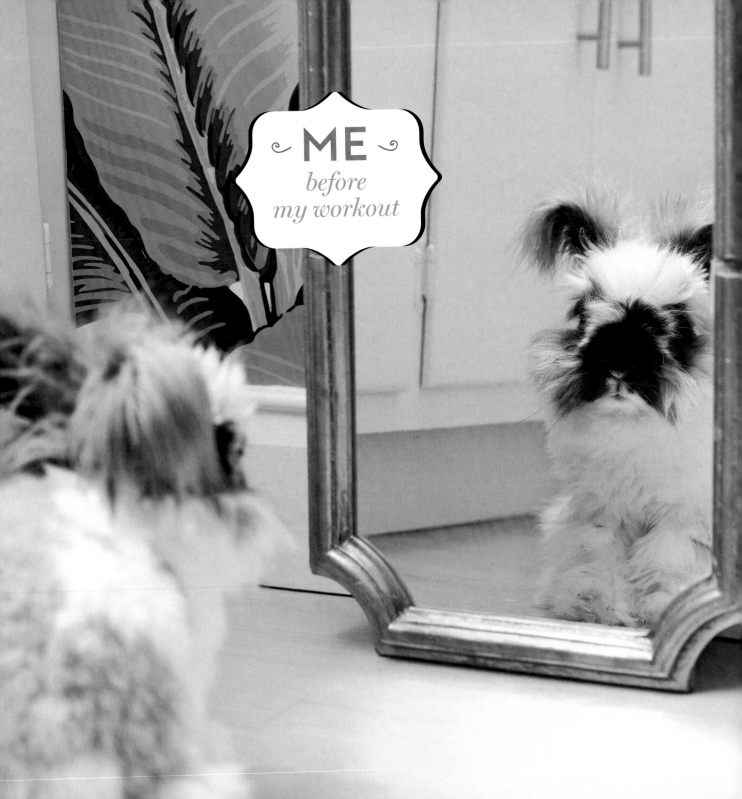

~ **ME** ~
*before
my workout*

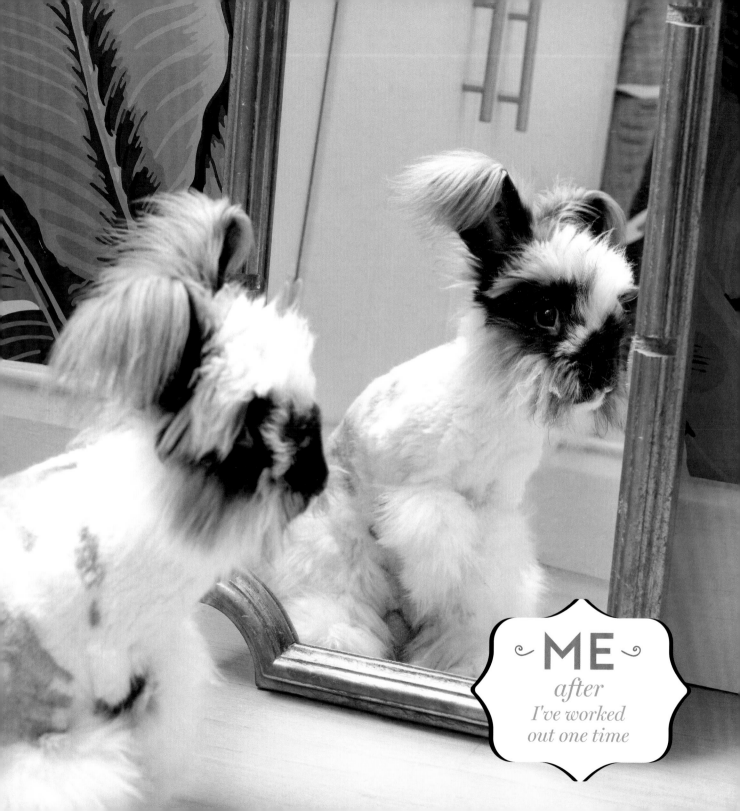

ME

*after
I've worked
out one time*

THE
bougie
bun

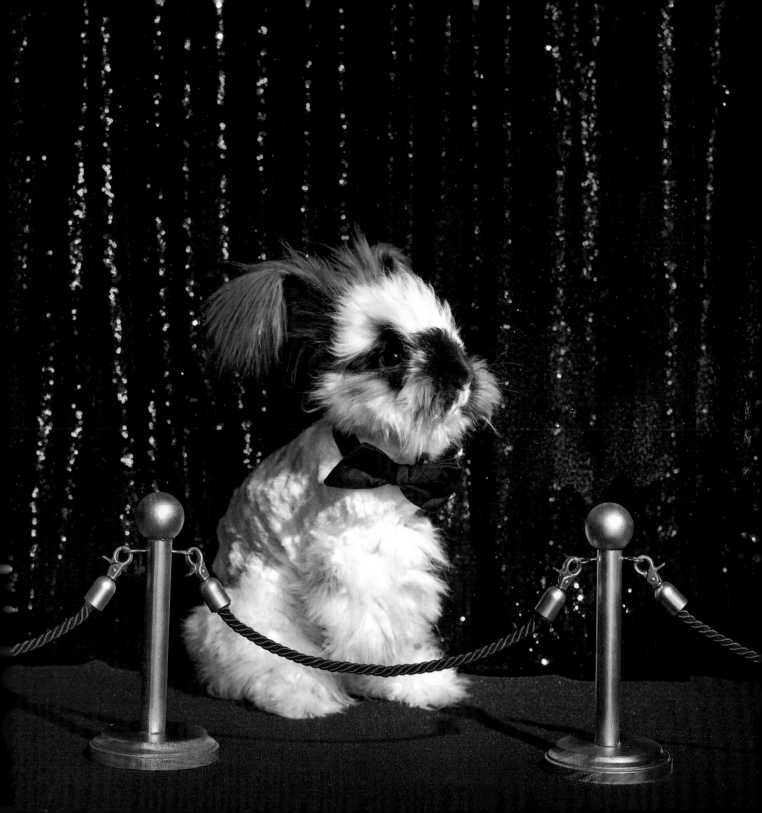

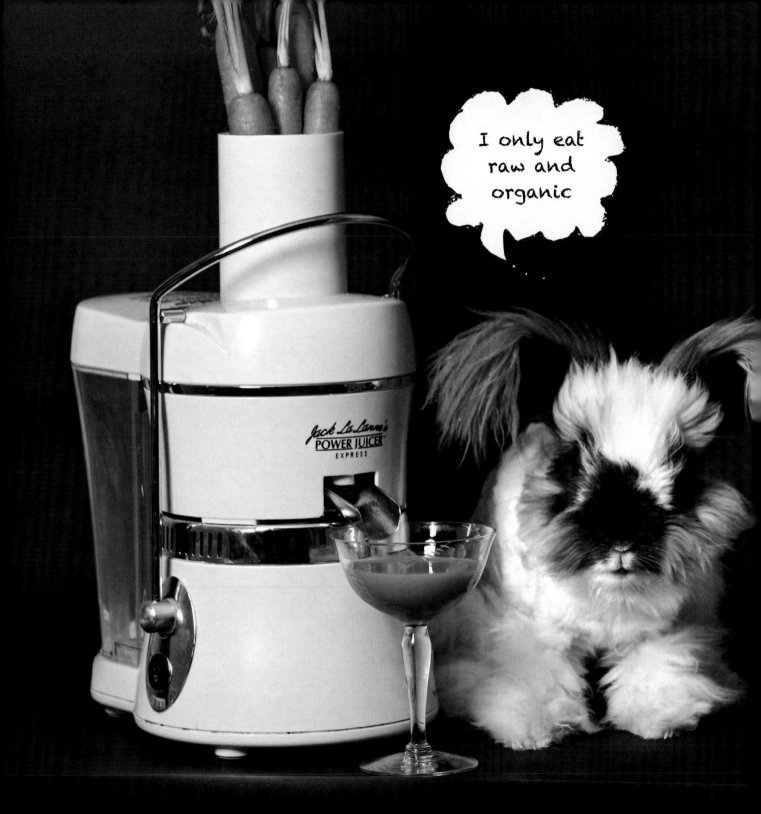

"Pearls are always appropriate."

—Jackie Kennedy

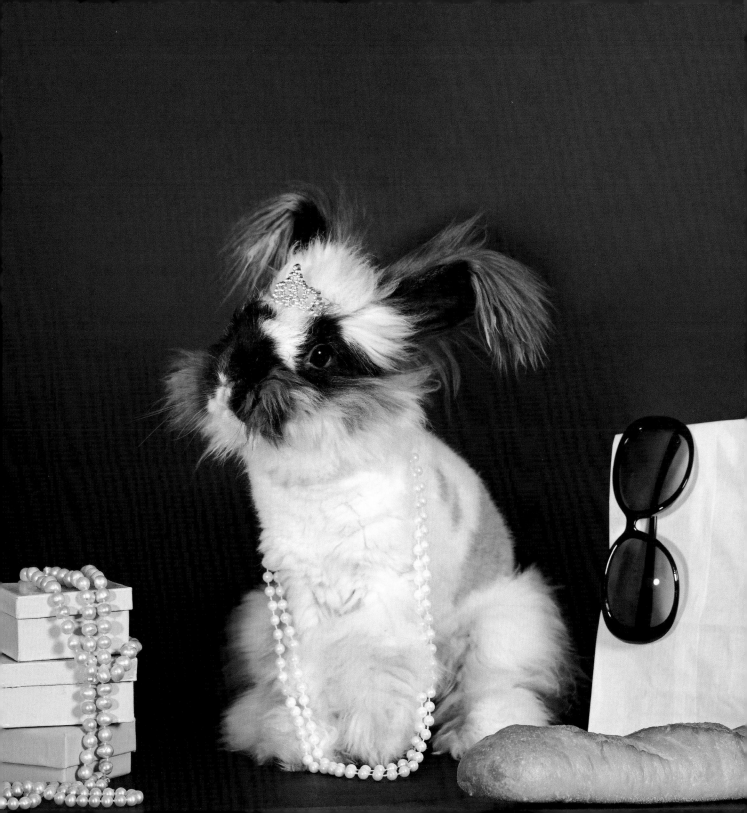

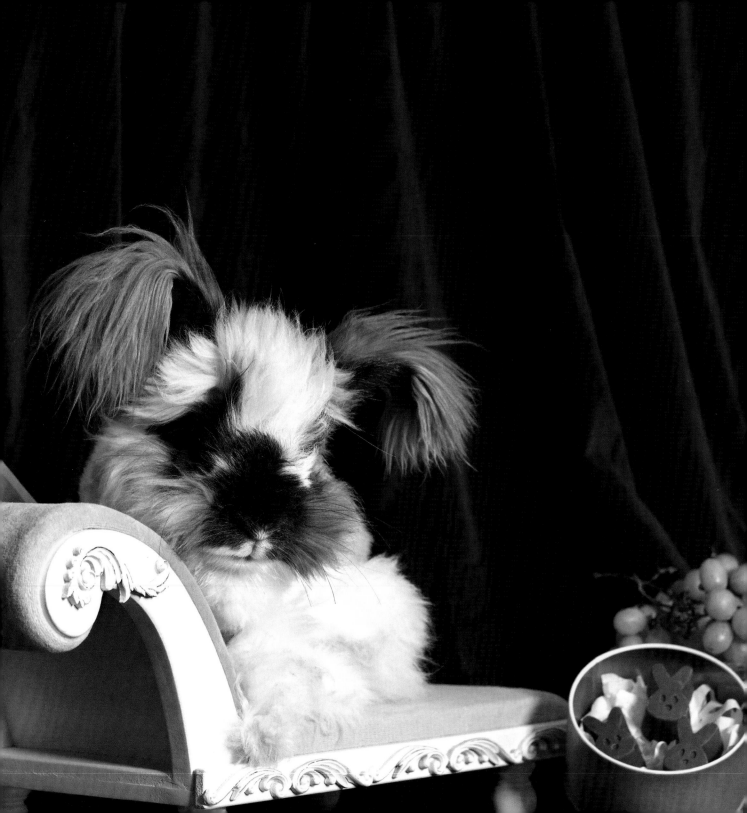

Frankly
my dear,
I don't give a

Hop.

THE
throw
back
bun

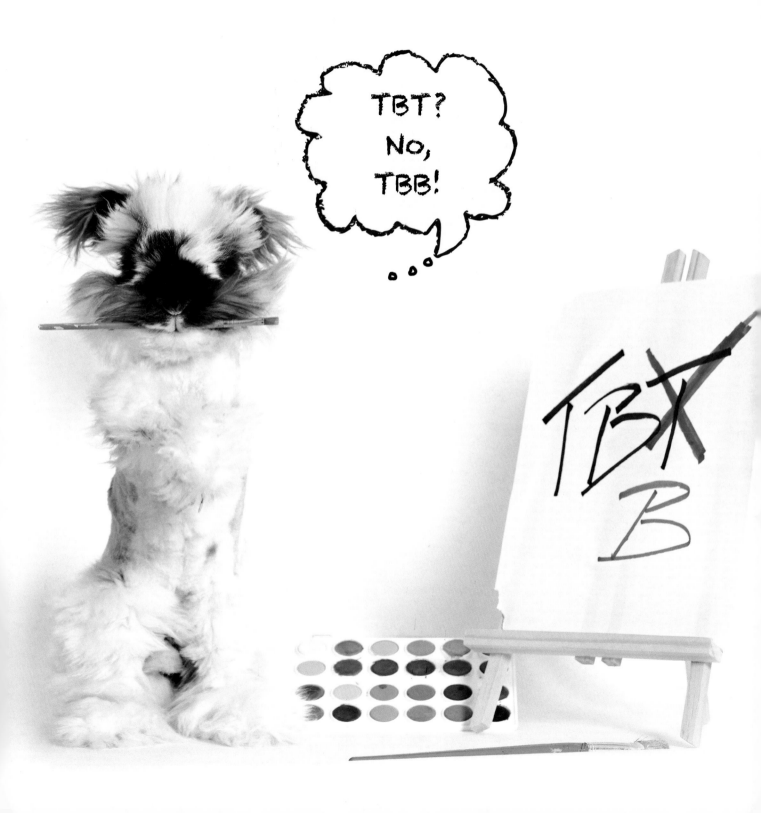

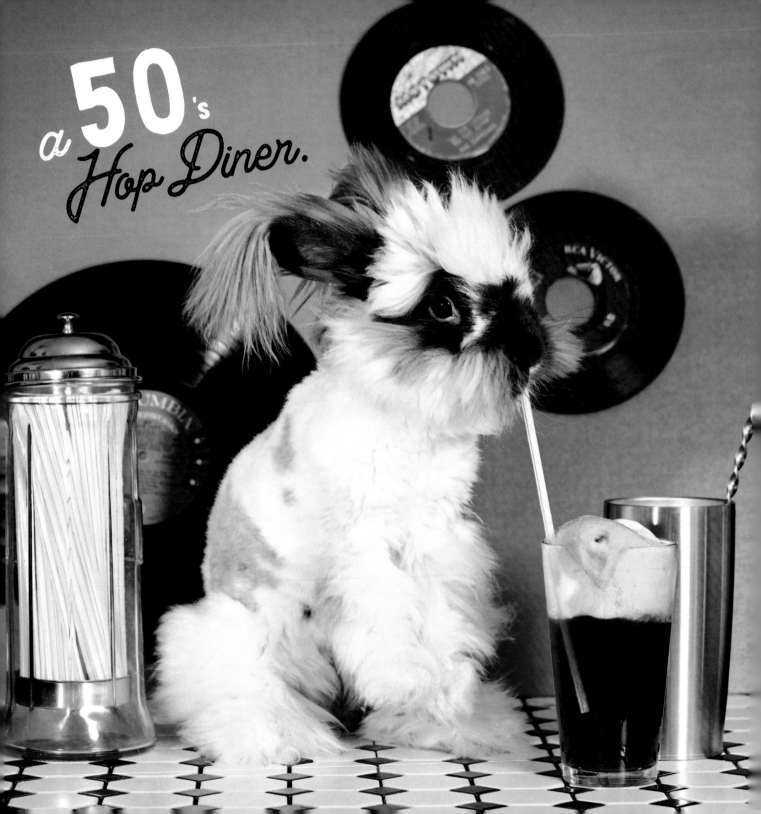

a **50**'s *Hop Diner.*

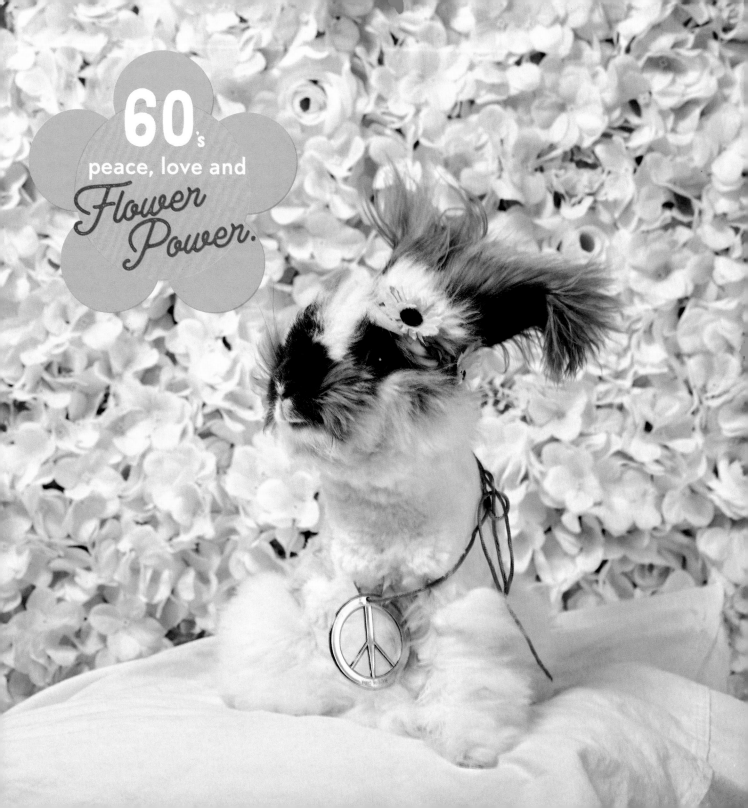

60's
peace, love and
Flower Power.

70's

Saturday Night

BUN.

80's
I'M *Pretty* IN
PINK.

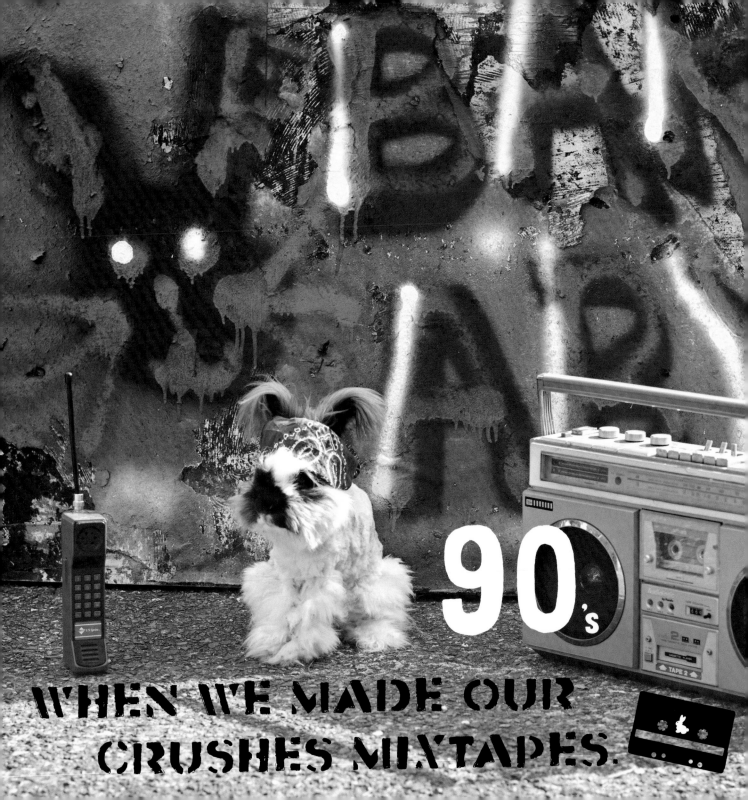

90's

WHEN WE MADE OUR CRUSHES MIXTAPES.

We all had that ONE

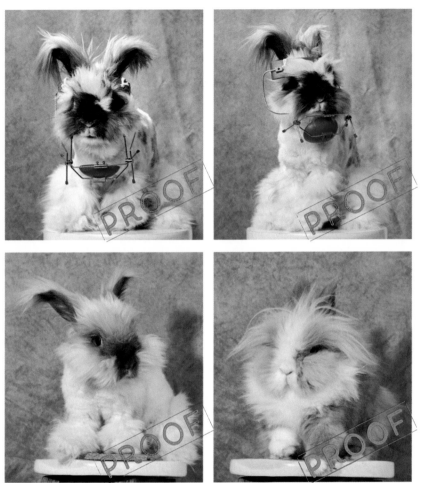

yearbook picture

THE
hipster
bun

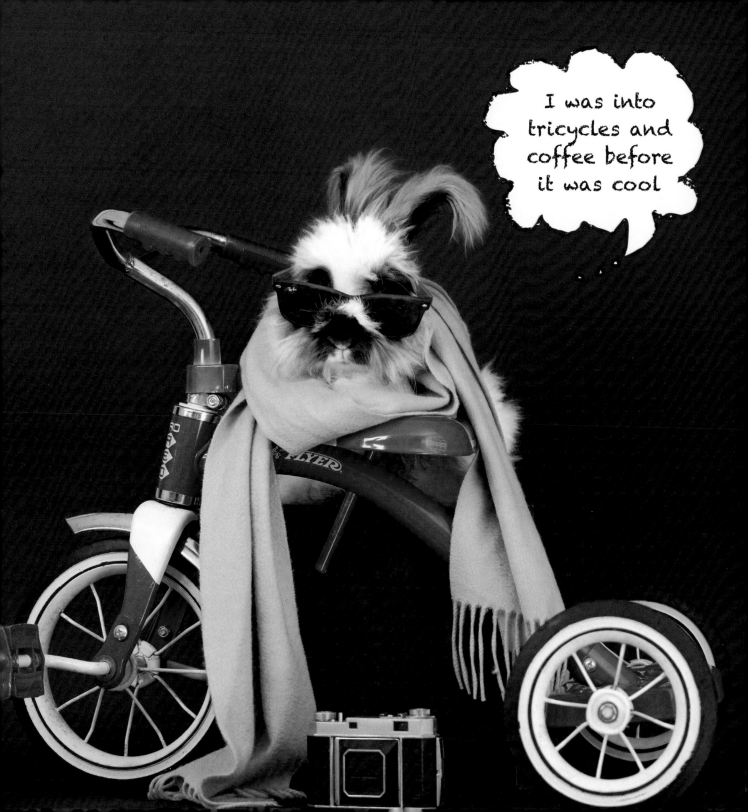

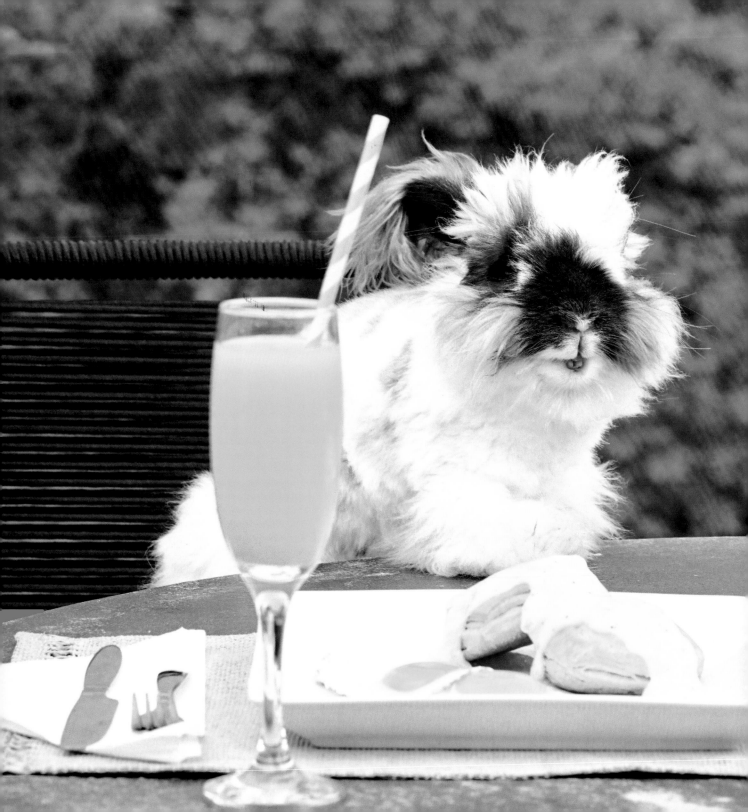

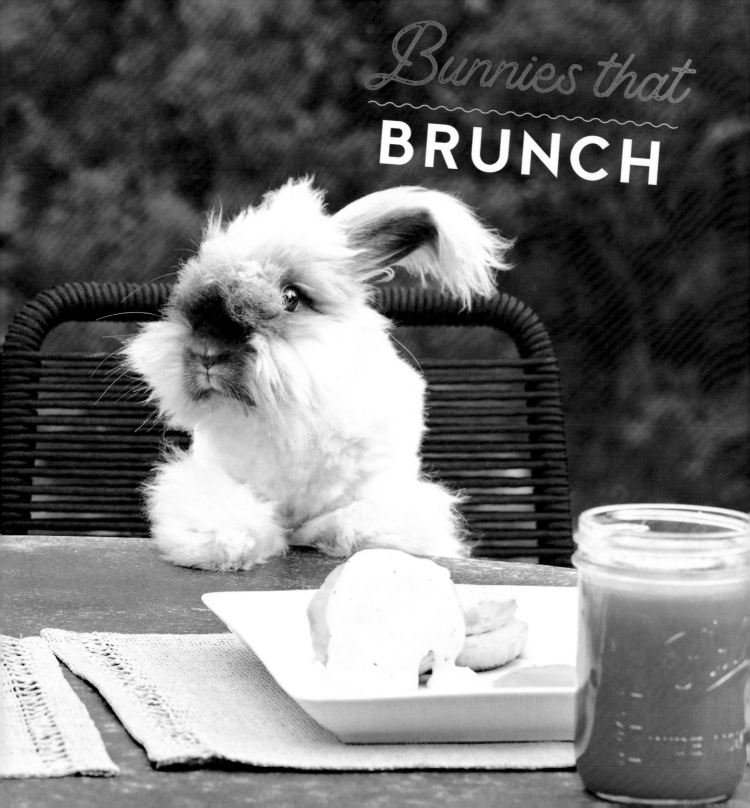

Bunnies that
BRUNCH

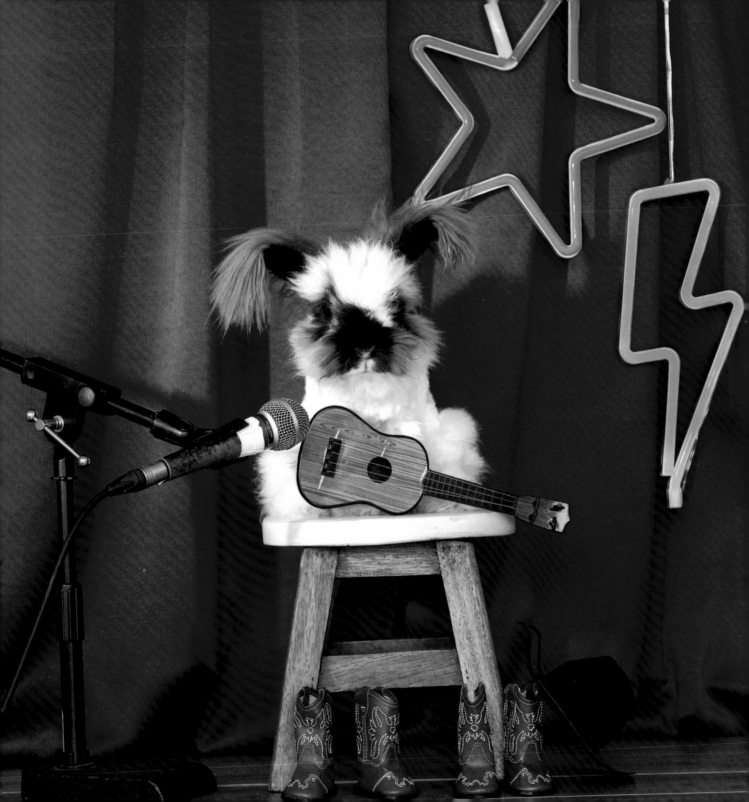

Will play for bananas

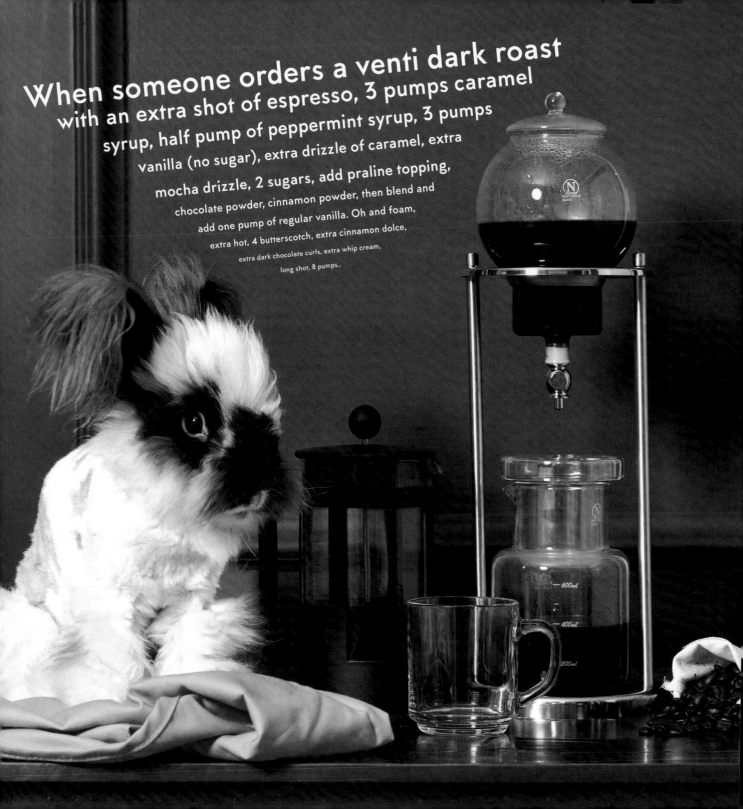

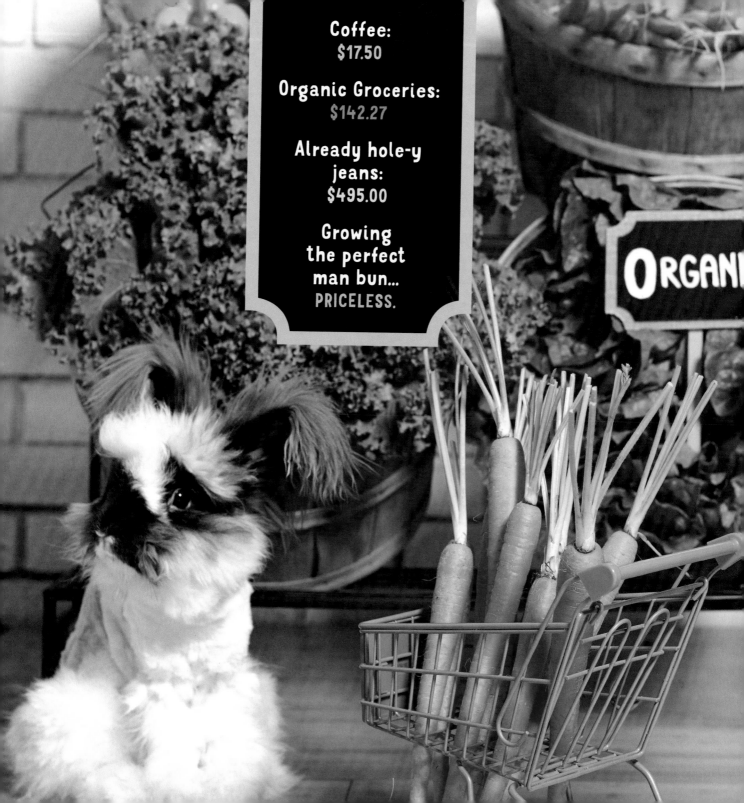

Coffee:
$17.50

Organic Groceries:
$142.27

Already hole-y jeans:
$495.00

Growing the perfect man bun...
PRICELESS.

ORGANI

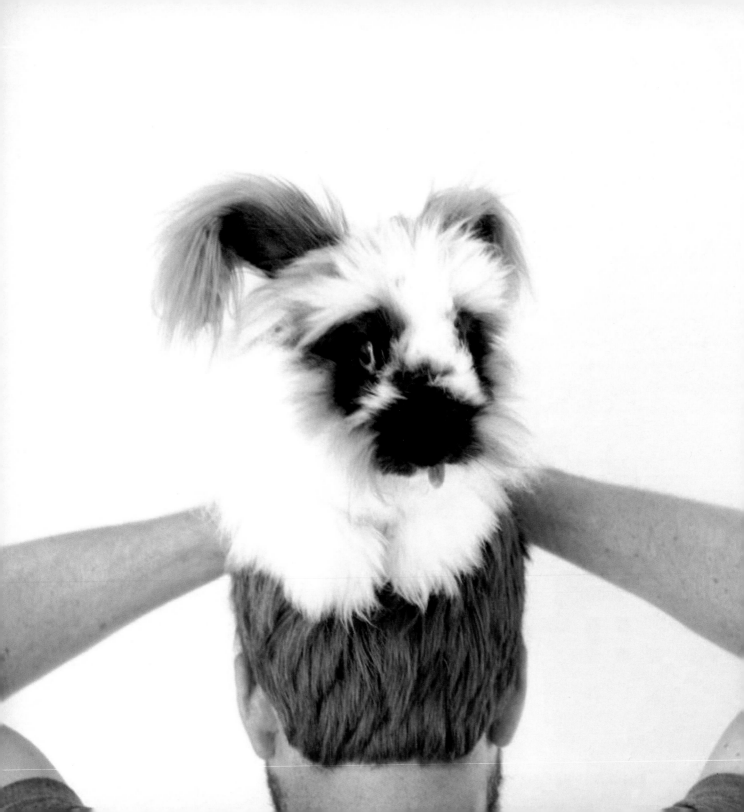

The best way to wear a
MAN BUN

STEP ONE:

Find a man.

STEP TWO:

Find a bun.

STEP THREE:

Carefully place bun on top
of the head and feed the bun
lots of bananas.

STEP FOUR:

There is no step four, this is the
only way to wear a man bun.

THE
worker
bun

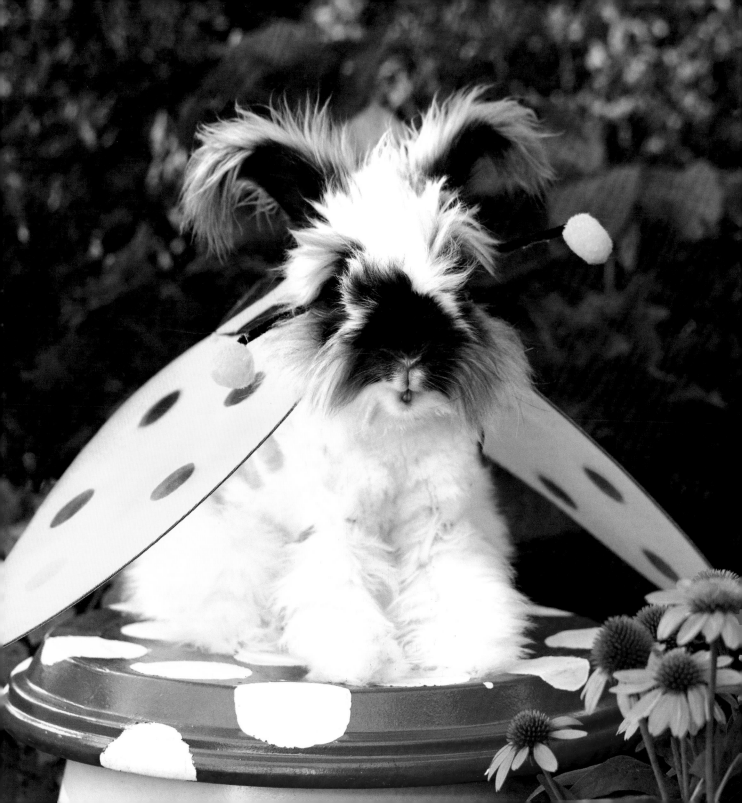

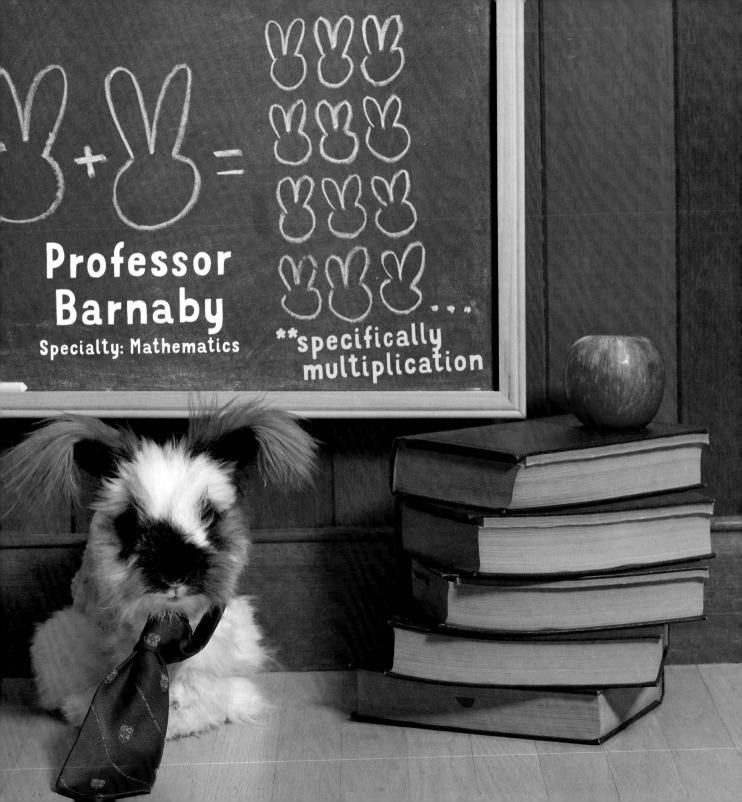

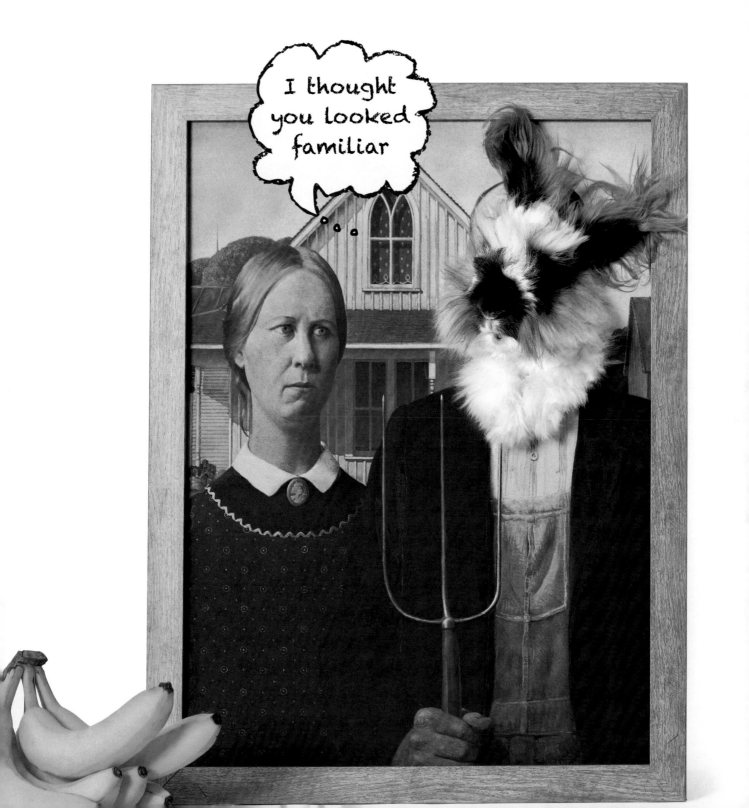

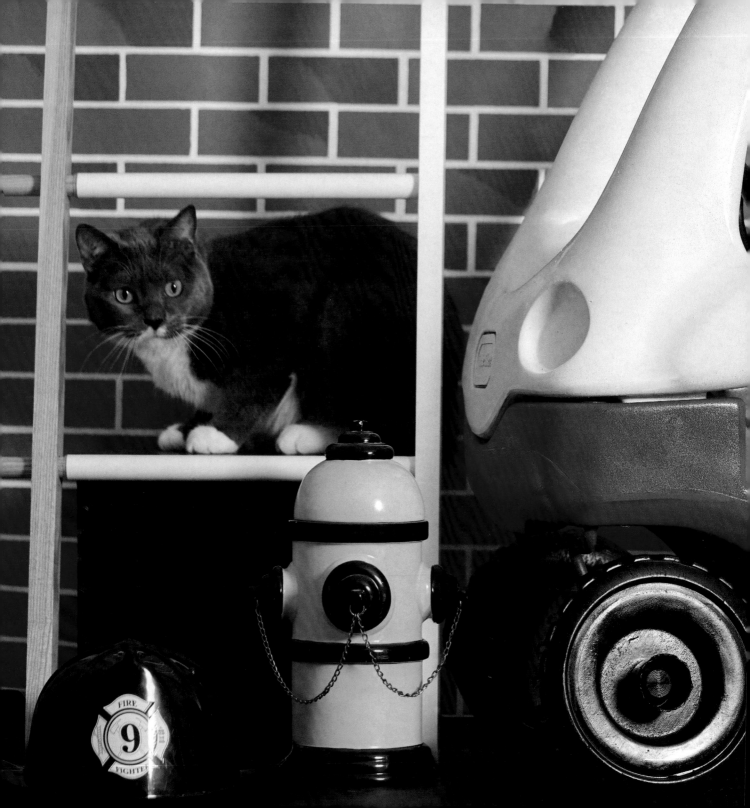

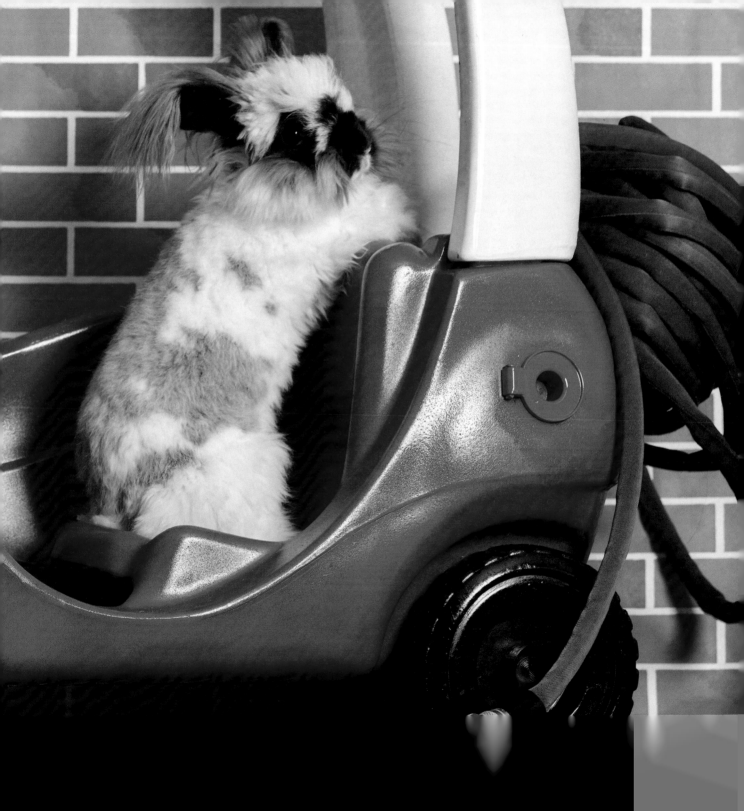

It's 5 o'clock somewhere!

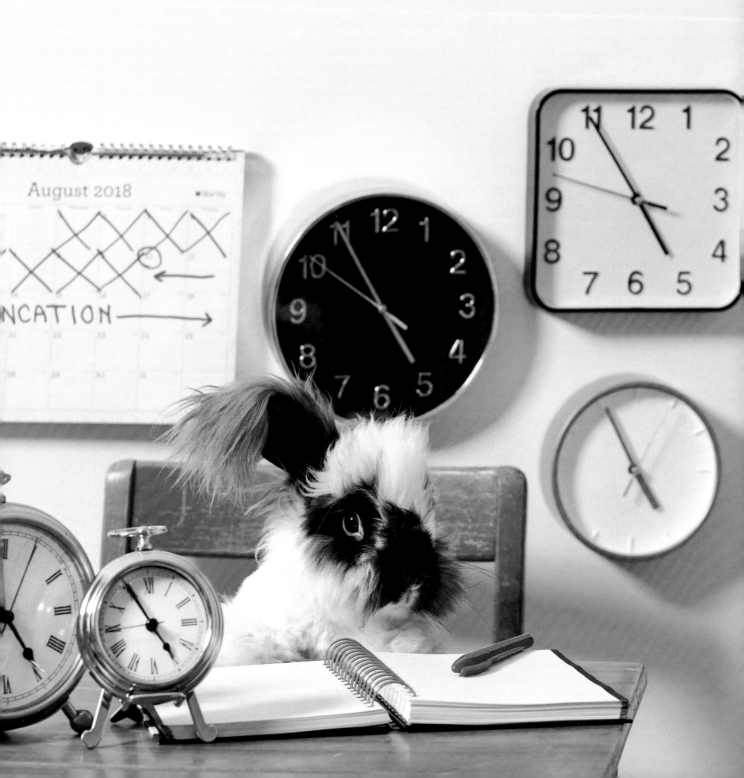

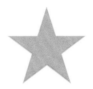

BUNNY WOOD

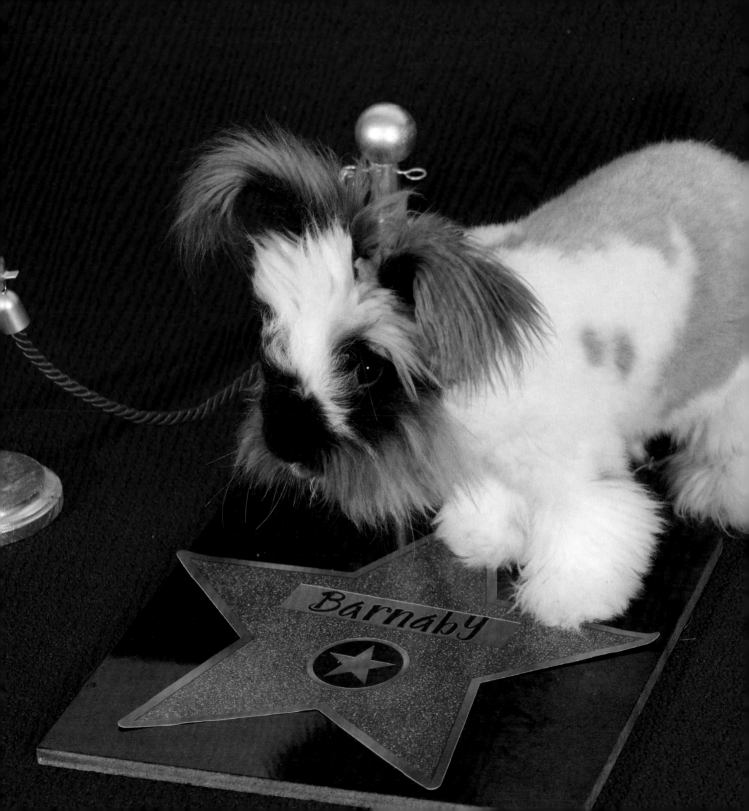

It's a BUN-NADO!

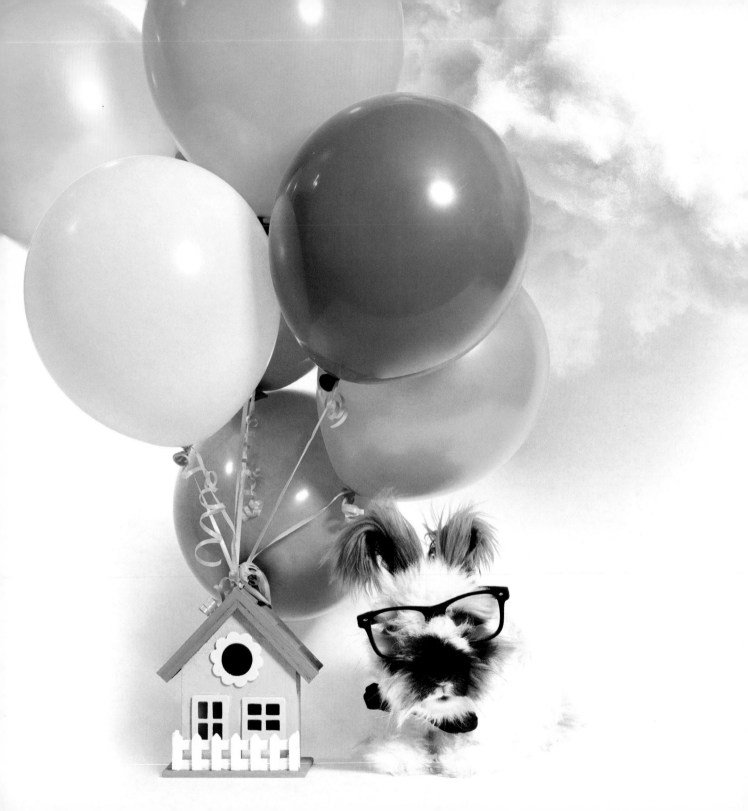

Adventure is out there!

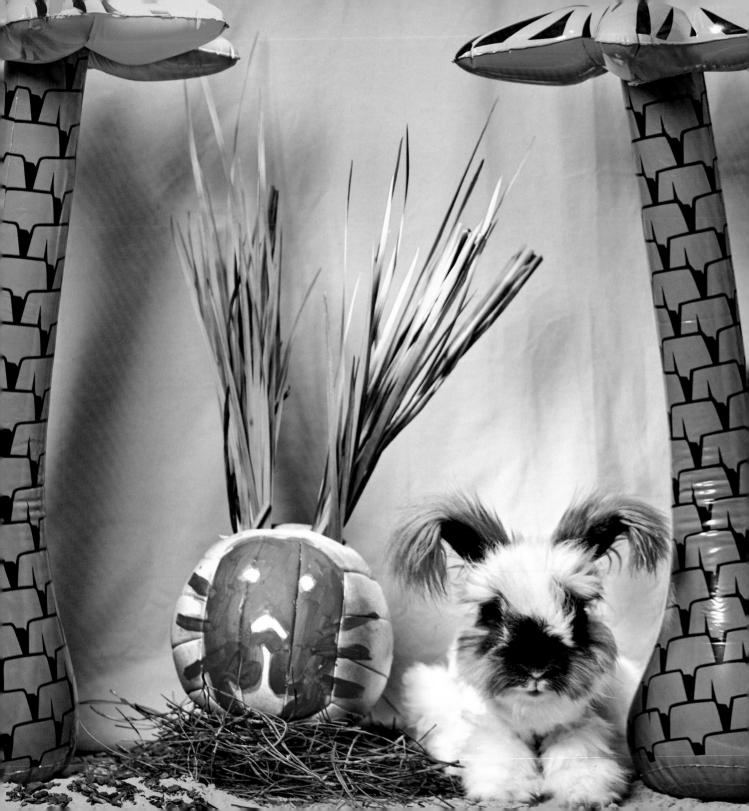

WILSON!

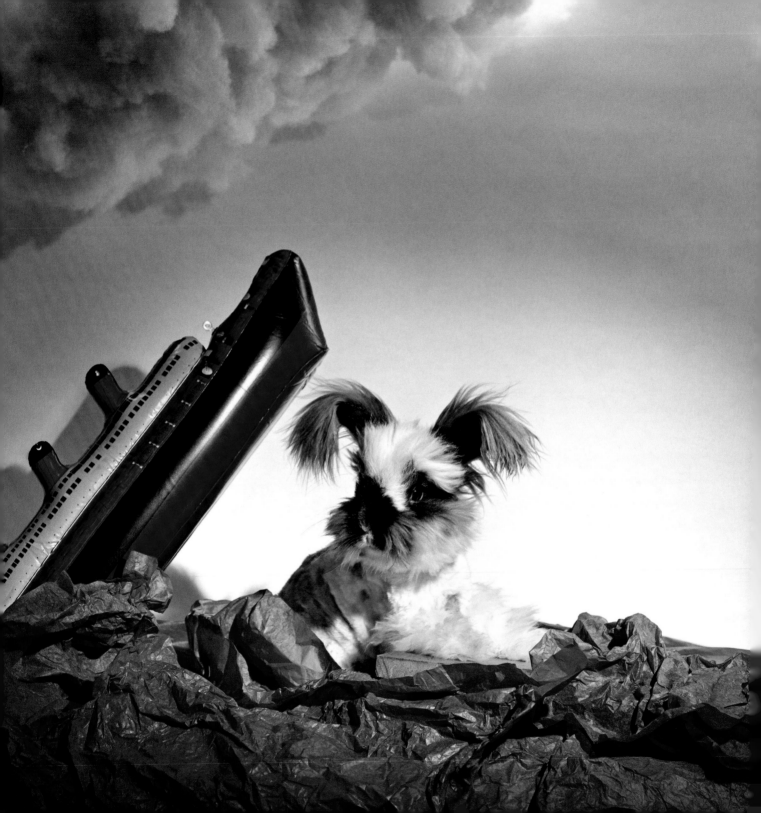

I'm the king of the world!

bun, bun, bun AND away

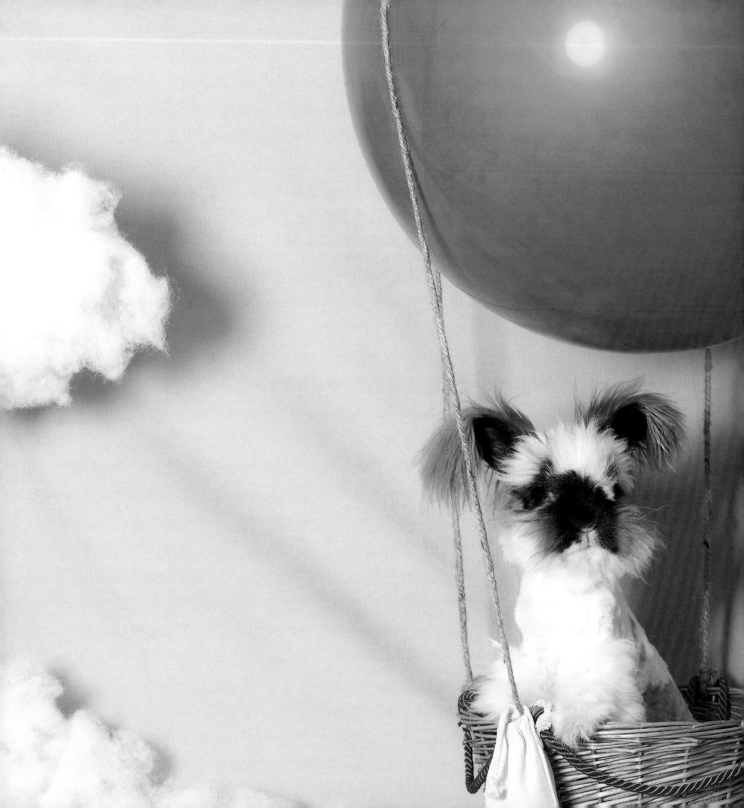

When trying to only pack a carryon.

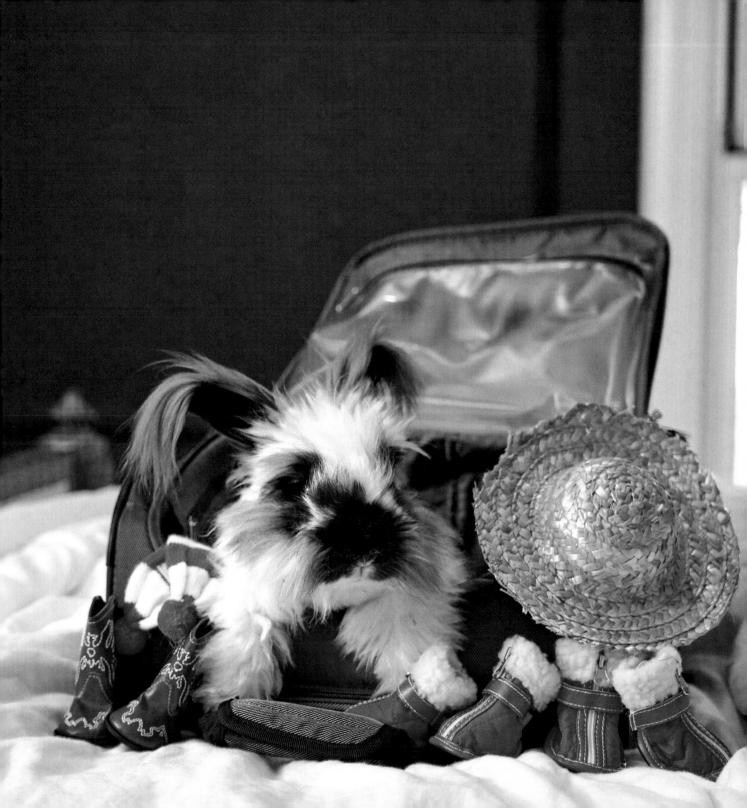

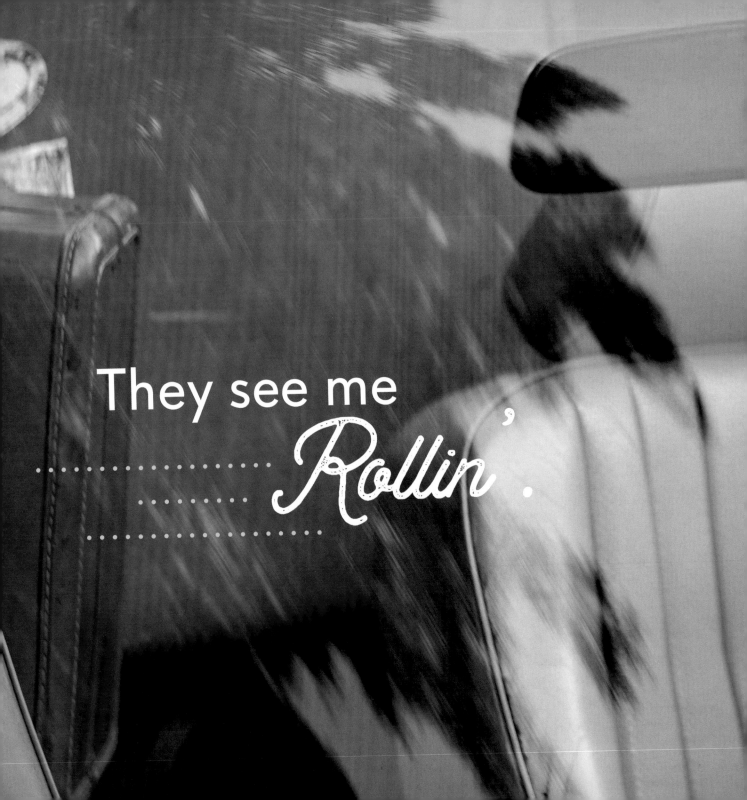

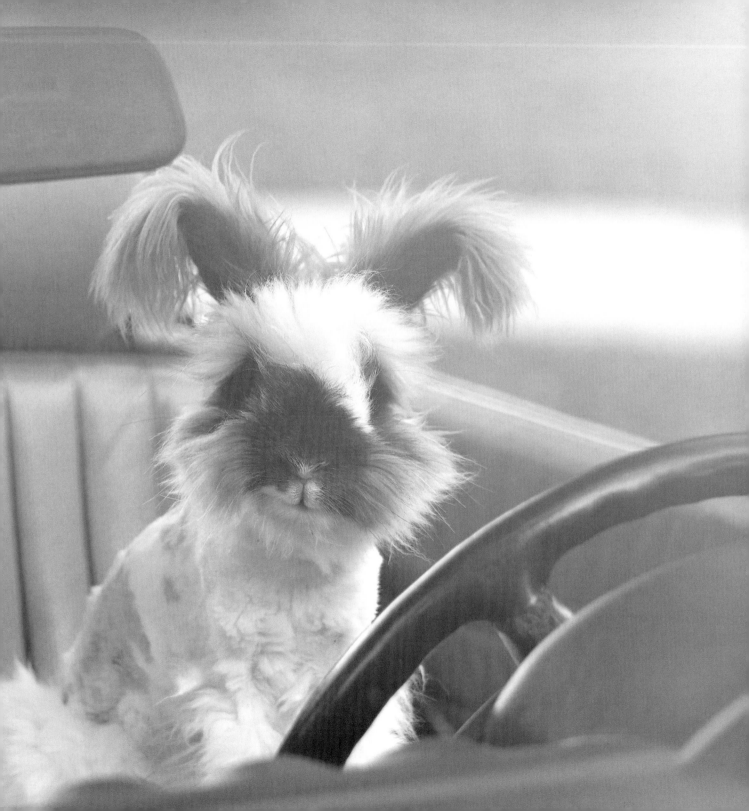

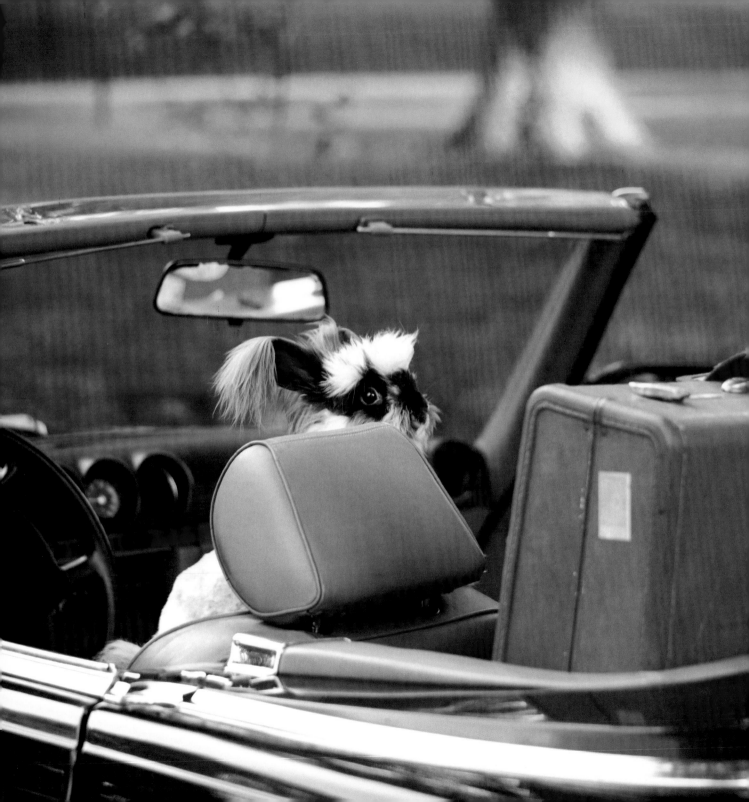

Catch ya on the HOP side.

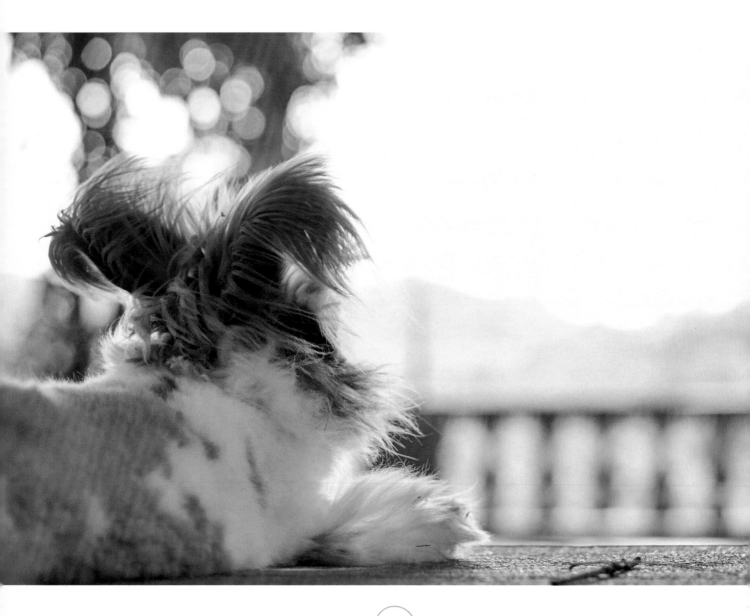

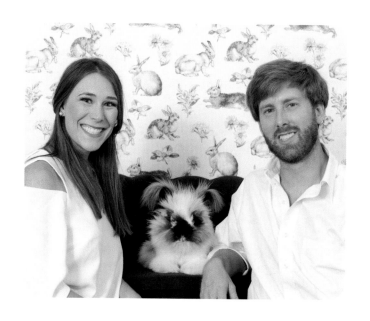

ABOUT THE AUTHORS

Katja Russell and Nick McGinn happily reside in Nashville, TN with their pets Barnaby, Britain, Benton, Cosmo, and Butler (the cat). Their hopes are to bring a smile or laugh to at least one person each day through their social media which you can follow @a_bunny_named_Barnaby

Bananas not included

ACKNOWLEDGEMENTS

First of all, we would like to thank each and every one of our followers. Without you, none of this would have been possible. Please know we read every comment, message, and tag. We have loved sharing our story and family with you throughout this journey, and have been so touched to hear about each of your own stories in return. Thank you, thank you.

Turner Publishing – Thank you for taking a dream of ours and turning it into a reality. Your constant support and dedication to not only us, but all of your authors is amazing. We are truly grateful to be a part of your family.

Stephanie – Where to start... a simple "thank you" does not seem sufficient. Thank you for your patience, support, guidance, advice, and most importantly, loving not only B, but all animals the way we do.

Heather – Thank you for all of the "I think we just need 30 minutes" meetings. Your patience and insight have been so valued, and we could not be happier that you are part of this amazing team.

Elise –Your sense of style and creativity is unbelievable. Thank you for the late night texts, prop runs, and all day photo shoots ending with tequila. Your eye for design is inspirational and truly what turned our vision into a reality. We could not have pulled this off without you!

Carey – Throughout this journey we have met so many wonderful and inspiring people, many of whom have become dear friends, especially you. We are so thankful for your help in opening our eyes to a world which we did not know existed and for helping us think outside the box.

Ashley – Thank you for your constant help and support when bringing these images to life. You are such a valued part of our team. We don't know were we would be without you.

Kathleen - Your "go get em" attitude is inspiring. Thank you for helping push this out to everyone and making this the best bunny book ever!

Our friends and family that have supported and encouraged us along the way, thank you for continuously pushing us to dream a little bigger and be our quirky selves. We love you.

And lastly, each other. From late nights compiling inspiration to long car rides bouncing around ideas. What started as going to the store for a fish net lead us to the best journey yet. We've always wanted to make at least one person smile a day, and if nothing else at least it's one of us. Love, love, love.